CATS OF ROME

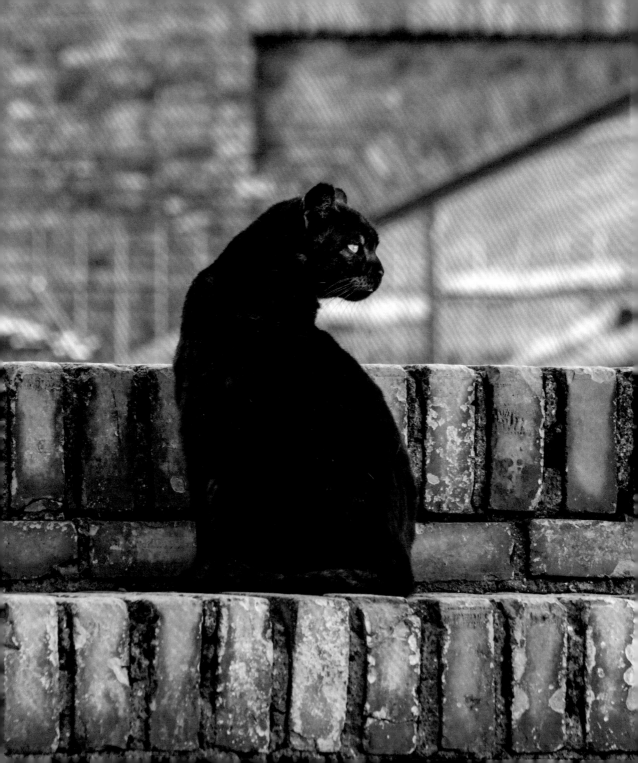

CATS
OF
ROME

TRAER SCOTT

PA PRESS

PRINCETON ARCHITECTURAL PRESS · NEW YORK

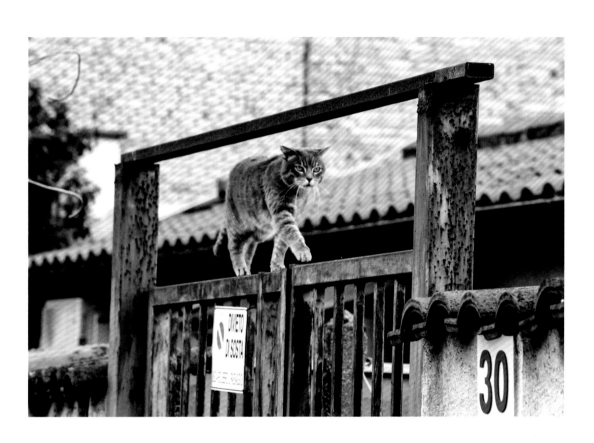

For Agatha,
my favorite travel partner.

———

And for Augusto and Tigretta,
the last of the
legendary Colosseum cats.

Published by
Princeton Architectural Press
A division of Chronicle Books LLC
70 West 36th Street
New York, NY 10018
papress.com

Traer Scott's Colosseum images (front cover, pages 102–7)
are included with permission of the Ministry of Culture—
Colosseum Archaeological Park.

Editor: Jennifer N. Thompson
Design: Natalie Snodgrass, Paul Wagner

Library of Congress Cataloging-in-Publication Data
 Names: Scott, Traer, author
Title: Cats of Rome / Traer Scott.
Description: First edition. | New York, NY : Princeton
 Architectural Press, 2025. | Summary: A collection
 of photographs of cats throughout the city of Rome,
 including iconic landmarks—Provided by publisher
Identifiers: LCCN 2024035587 | ISBN 9781797231280
 ebook | ISBN 9781797231273 hardcover
Subjects: LCSH: Cats—Italy—Rome—Pictorial works. |
 Rome (Italy)—Pictorial works.
Classification: LCC SF442.63.I8 S26 2025 | DDC
 636.8009456/32—dc23/eng/20240809
LC record available at https://lccn.loc.gov/2024035587

Contents

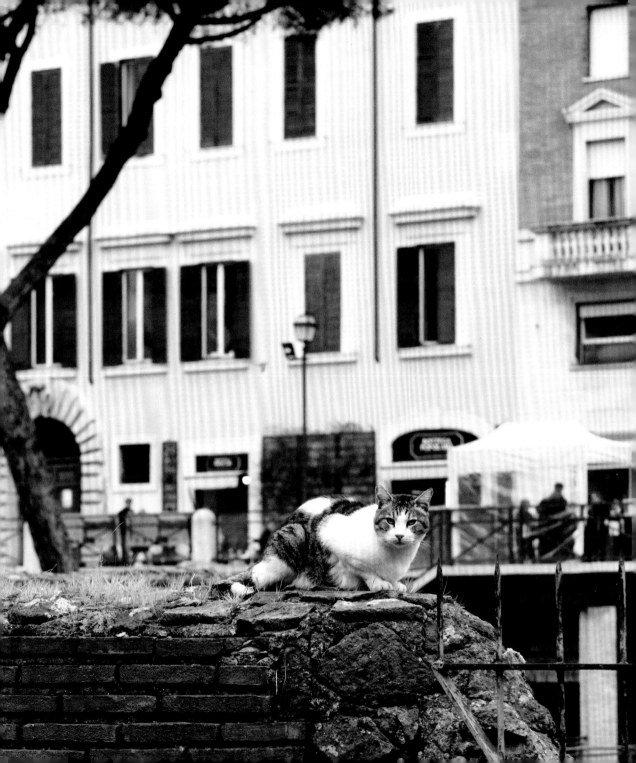

INTRODUCTION

Rome is a tangled anachronism, a city where the ancient is strangled on all sides by the chaos of twenty-first-century life. In central Rome, tourists throng the sidewalks, streets, and alleys morning to night. Visitors from all over the world come to touch and commune with the art and relics of ancient life, to eat the famed Roman pizza and colorful gelato that are offered on every corner. At midday the twisting streets almost appear to offer the crowds up to the Mediterranean sun, as if to unburden themselves.

Amid the explosive human presence in Rome there is a significant yet largely hidden animal presence: tens of thousands of feral cats who are protected by law and live quietly in architectural ruins, parks, and neighborhoods around Rome. So quietly, in fact, that if you're not looking for them, you probably won't see a single cat while you're there.

But they weren't always so hard to find. When I first came to Rome in 2001, the cats were everywhere: in the Colosseum, in the streets, yowling from behind trash bins at midnight.

While the feline population in the Eternal City is still there, they are now fewer in number and more safely contained. This time, I saw cats on tote bags and mugs in Roman gift shops way before I saw any real ones in the city. The cats of Rome are still a playful symbol of the city but, due to effective trap-and-release sterilization, they are far less visible and prevalent than they once were.

These days the cats mostly live in parks or protected areas, fenced archaeological sites, and the slightly rundown parts of neighborhoods. There are an estimated four thousand feral cat colonies in Rome, a colony being defined as two or more cats living together in regular place. Most

INTRODUCTION

colonies range in size from five to forty cats, all of whom need feeding at least once but usually twice a day. This is the job of the gattaras, the often nameless and plentiful women of Rome who volunteer to care for the feral cats.

The gattaras in Rome appear to be crepuscular, much like the cats they care for. Most of these female caretakers arrive to feed their feline colony before sunrise and again at twilight or just after the sun has set. These are the times when there is the least interference from people and other urban animals, the quietest times of the day. But these "cat ladies" are not the gattaras of urban myth—crones with bent backs, long skirts, and headscarves—rather, they are modern women with modern lives.

Some gattaras are retired, but the younger women work. They come from all walks of life. One woman I met spent decades cleaning offices overnight. When she was done in the morning, she would go directly to feed the cats. Though she had begun caring for the colony while she lived in the neighborhood, she has long since moved away but takes two buses every day to come to feed the colony that has depended on her for thirty years. Another gattara finishes her nine-to-five job and immediately heads out to feed the cats;

only after she has done that does she go home and care for her own little feline family, all of whom were once ferals who couldn't make it on the streets.

The cats know their caretaker's voice, their step. Their internal clocks are sharp; they know when to expect their ladies and often you will see them emerge from their naps under trees or tarps in unison, stretch, and then plant a stare in a particular direction, expectant. When the gattaras arrive, they call each cat by name and one by one they all come running to their meal.

Once a gattara registers a colony with the city, she receives special access to the area, perhaps keys to a gate, and permission to build a shelter. The city posts a sign designating that the space is home to a protected cat colony. The city also supplies bulk dry cat food to the city's cat colonies but many of the felines turn their noses up at the plain food and refuse to eat it. As a result, gattaras often provide canned food paid for out of their own pockets or, in some cases, through community donations.

Sometimes the gattaras endure threats and insults from neighbors who don't like the cats or don't want them near their homes, but they are undeterred. Caring for the guardians of the Eternal City is a calling and they are devoted to their charges,

giving a huge part of their life over to the care of these iconic Roman residents. Rights are often passed down from one gattara to another once an elder becomes too infirm to walk the route every day.

Rome's most famous attraction is also the most notorious place to find its famous cats, or at least it was until recent years. The Colosseum draws sixteen thousand visitors every day, and while most people brave the long lines, heat, and extreme crowds once, I have gone five times. By my last visit, I knew the system so well that I could get from the bus stop on the street to the inside of the amphitheater in under five minutes, a remarkable and somewhat blasé feat.

The first visit on this trip was with my family, who accompanied me for a week, and we floundered through the process like most tourists do. We stood in line, went through the passport check, then metal detectors and finally were deposited, somewhat flustered, in the mouth of the Colosseum, a central spot thronged with families and tour groups speaking every language imaginable. We began the slow march around the inner circle, climbed the stairs to the top level to escape the crowds, and, while my husband talked about history, I looked in every arch and shadow for cats, but there were none.

Twenty years ago, when I first came to Rome with my then fiancé, there had been cats everywhere, comparatively few people, no rules, certainly no metal detectors. I don't think we even paid to get in. I remember roaming around the upper level, touching bricks, taking photos that had no people in them. It was a little magical back then, but now, as in so many of the world's best spots, the magic has been chipped away in the name of safety and preservation.

On this visit, there are two gift shops, a large one in the center and a small one near the exit, both with cat wallpaper, playful little black cats frolicking up and down a white background. There is cat merch: t-shirts, pencil cases, but no actual cats.

I decided to ask the Colosseum employees where the cats were. The first man I approached didn't speak English, but the second was amiable and explained in halting English that the colony had been moved across the street to Domus Aurea. As with many people I spoke with, there was fondness in his voice as he spoke about the cats. Most importantly, I learned that there were only two cats left in the Colosseum:

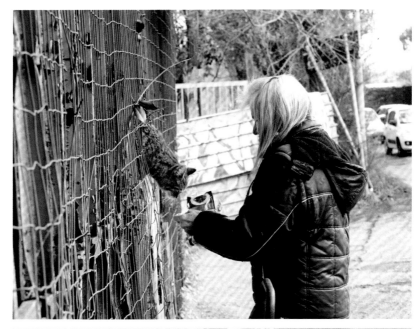

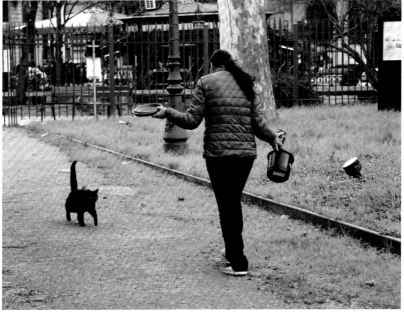

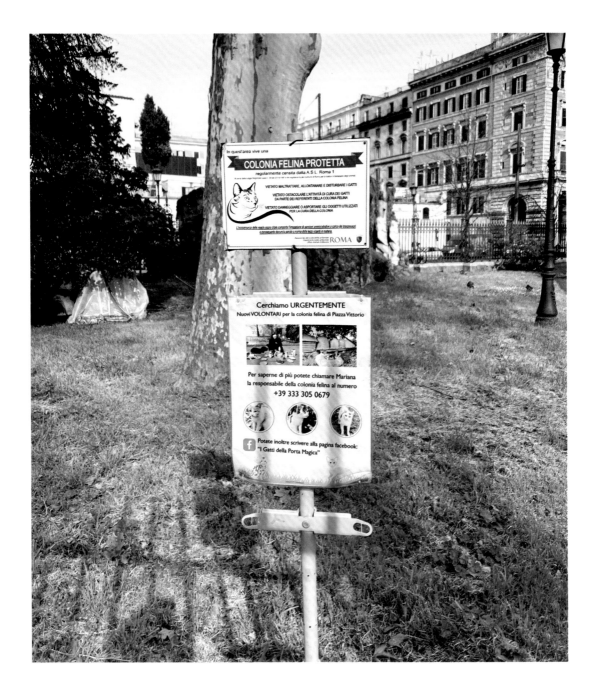

Augusto and Tigretta. When I asked where to find them, he said to go to the exit; one of the cats was always napping in an archway there.

But when I got there, of course there was no cat. I asked another employee where the cats were, that I had heard they were at the exit. He laughed, as if I had been tricked, and told me no, they have beds and bowls near the gift shop. Which gift shop? I asked. He pointed. It was the one near the exit. Another puzzle piece fit into place, but it was too late to explore since we were already being ushered out of the gate. I decided to come back alone once my family had left.

I chose a cloudy, cool day, one ideal for photos and, I thought, for cat sightings, logic being that the coolness would send the cats out into the open seeking sun and warmth. This time I bypassed the barricades put in place to herd people through the one-way circle and headed straight to the gift shop near the exit. I spotted the cat beds and bowls, which lay behind a rope closing the area off to the public, and smiled to myself. But still no cats. This time I asked a female employee where the cats were and was told that Augusto was inside the employee lounge on the couch in front of a heater. It was after all, in the mid-sixties, she said, quite cold for most Romans, and on cold days he stayed inside. I asked hopefully if he might come out and she said laughed and said, oh no. Better to come back on a sunny day first thing in the morning, she said. What about Tigretta, I asked? She told me that Tigretta was the most elusive of all, only showing up to eat after the public was gone for the day and then slipping back into the shadows of the ruins. I left feeling that these cats were more akin to ghosts, two more spirits to inhabit this ancient spot where so much human and animal blood had been shed.

On the third visit I arrived at 8:40 a.m. and was among the very first people let in. I made a beeline for the gift shop at the exit, passed the beds and bowls, which looked freshly licked from breakfast, rounded a corner, and there he was—orange Augusto sitting on a brick column with his eyes closed, relishing the morning sun. Augusto is eight or nine, or maybe eleven or twelve, depending on who you ask. He has feline HIV. He gets better care than people do. These are the things I learned from the huddle of employees near Augusto waiting to start work that morning.

Even though Augusto is a star stalked by tourist paparazzi all day, he is immune to

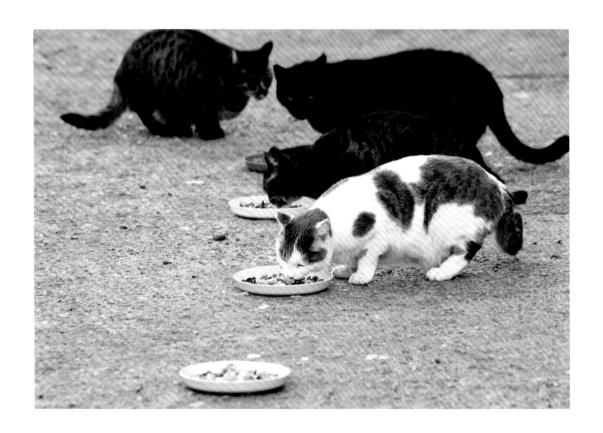

INTRODUCTION

the attention and chooses mostly to remain in sight but out of reach. Elusively available. When I first spotted him, he was close enough to touch, and after I took a few photos I reached my hand out and stroked his rough fur. I couldn't help myself, even though I should know better. He responded favorably to the touch, pushing his head into my hand a little. I was encouraged and petted him on the head and then the back, but nope, too much. He jumped up, arched his back, tail straight in the air, and moved out of reach. I was greedy and now I had lost the shot and my new friend.

I followed him and began to talk to him, coaxing him. He seemed annoyed. I was coming between him and his sleep. He moved again but, as luck would have it, this time to a perfect spot, photographically speaking. I didn't try to touch him. I just stepped back and aimed the camera. My restraint was rewarded with the perfect shot.

The last time I saw Augusto, a kind staff member whom I had spoken to before lifted the ropes and let me into the employee-only section where he was hanging out that day. Knowing this was likely my last chance to photograph him, as well as my last few minutes in the Colosseum possibly ever, I abandoned all self-consciousness. I dropped somewhat painfully down onto my knees and then just lay down on my side on the cement floor. People rightfully gawked at the middle-aged American woman lying prostrate in front of a highly judgmental cat, but I just clicked away, in full photog mode, oblivious to wide eyes and whispers. Augusto stared at me for a little while, yawned, and then arranged himself in loaf form and went back to sleep. As I thanked him and said goodbye, one of his eyes opened a hair and I felt seen.

Another much lesser-known colony that I visited frequently was the Porta Magica colony in Piazza Vittorio Emanuele II, the largest piazza in Rome. Behind thick iron gates, Porta Magica, or the Magic Door, serves as a backdrop to the home of several dozen cats. Porta Magica was created as one of five garden gates in the mid-seventeenth century by Marquis Massimiliano Palombara, a wealthy aristocrat and owner of the lush Villa Palombara. According to legend, on a stormy night in 1680, a traveler thought to be the alchemist Francesco Borri stayed the night in the villa. While there, he went to the garden in search of an herb capable of producing gold. The next morning, the alchemist had mysteriously vanished, leaving behind flakes

of pure gold and obscure instructions believed to be a secret formula. The marquis was sure that the mysterious writing contained the secret of the philosopher's stone (a mythic alchemical substance believed to turn any metal into gold and to make an elixir that renders the drinker immortal) and had the secret symbols engraved on the door, hoping that one day they could be deciphered. Legend says that anyone who can decipher the formula will be able to pass through the Magic Door. The cats often sit in front of it, seemingly challenging anyone who might try to gain entry.

During my second week in Rome, spring had tiptoed in and already the temperatures were swelling into the mid-seventies at the height of the day. The piazza was full of activity: people and many species of animals had come out to bask and play in the sun.

Birds of paradise flowered along the grassy edges of the park, and bushes exploded with bright yellow flowers. Always dodging the hot sun, I was cowering in a sliver of shade on a bench when I became aware of intense bird chatter coming from the palm tree above me. Birds, lots of birds. They were so loud that they drowned out most of the city noise from the street that

was only twenty feet from me outside the park gates, so loud the sound hurt my ears. They sounded exotic, their chatter almost articulated. Parrots? But how could there be wild parrots in Rome?

I saw rustling in the dense fronds and out flew a dozen green birds followed by several dozen more. They did a joyous loop around the park and then ducked back into the shade and safety of the tall palm. I recorded the sound, made a note of their markings, and later found out that they were monk parakeets, a parrot species native to South America. Apparently, a number of these parakeets escaped from aviaries in the late seventies and early eighties. The birds established breeding colonies and managed not only to survive but thrive to the point of becoming invasive. I found them enchanting. They live high up in the palms so the cats of the colony can never really get a good glimpse of them, unlike the copious pigeons who are always hanging around the monuments where the cats live waiting for scraps from their meals.

At the entrance to the park there is a clock with no hands. Maybe we are meant to forget about time while here, and I always seemed to. At one point I realized that I had been under the green parrot

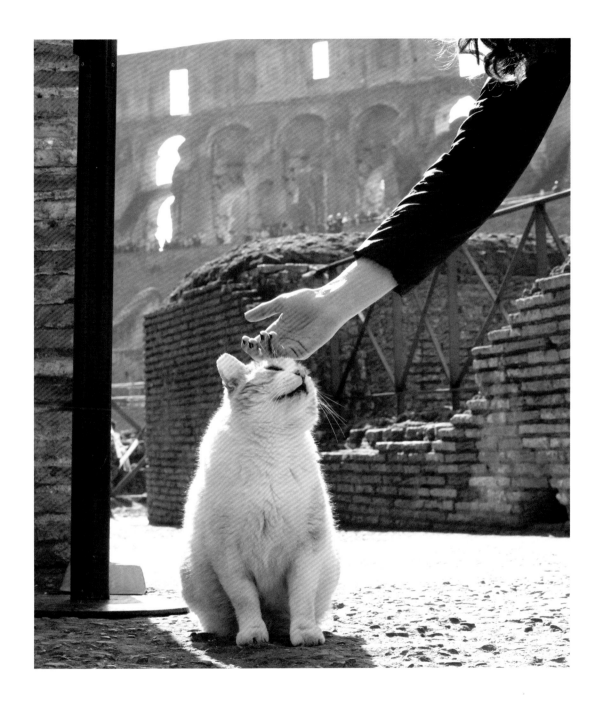

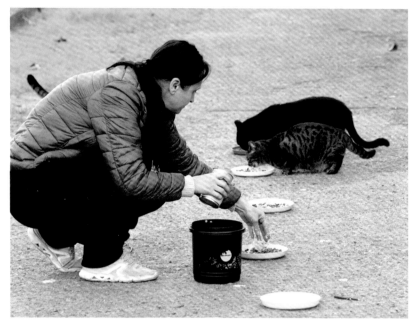

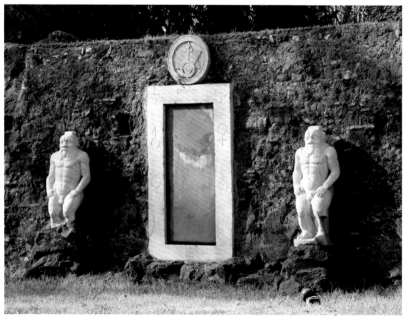

INTRODUCTION

palm for almost four hours waiting for a cat to walk in front of the portal. I felt deflated, like I had wasted my day. I texted my husband and he said, "Well, aren't there plenty of photographers who camp out for days waiting for a snow leopard?" I smiled. My cats are just as important as a snow leopard. Smaller, maybe a little less majestic, but my cats are guardians of the Eternal City, well worth waiting for.

The next week I got to meet one of the Porta Magica colony's gattaras and she took me inside the gate surrounding the ruins. (Like all of the iron gates fencing in sites and colonies, the bars are spaced too close for a human to get in but wide enough for the cats to come and go.) I tried to stay out of the way; I was a stranger, and the cats were afraid of me. Behind the bars they had full agency of when and if to approach people, but with me on the inside, they felt threatened.

As I tried to disappear under tree branches, the gattara lined up plastic plates and began to spoon wet and dry food onto them as she called out the cats' names. Seagulls who had also figured out the feeding cycle began to swoop down, trying to steal food, but they were shooed away. Undeterred, they continued until she put a separate plate out for them. While I skirted the perimeter and took photos, she fed the colony. As it was getting dark, I found myself right next to the Magic Door. I dashed over, laid my hand flat on it, and closed my eyes ever so briefly. I had to try, had to feel the stone that perhaps held an enduring alchemical secret, but, perhaps luckily, nothing happened, so I returned my focus to the cats.

The gattara and I communicated through Google Translator. She told me that there were three other volunteers at the colony, but that she did the bulk of the feeding shifts. I asked her how many cats were in the colony, and she said, "Trenta gatti," thirty cats. Where were they all? I only counted a dozen or so. Out and about, she said. I wondered where. I looked at the untouched plates of food and asked, did the food ever draw rats? "No rats!" she said in English. "Perché no?" I asked. "Trenta gatti!" she said with a smile. I felt foolish. Of course there were no rats with thirty cats around.

But despite the feral cat population, Rome is said to have more rats than any other major European city. Critics point to sanitation issues like overflowing trash bins, a problem that is evident as soon as you get out of the touristy city center, but I have to wonder if the well-fed cats aren't partly to blame.

One area of Rome that most likely has the least rats is Largo di Torre Argentina, the architectural ruins of four Roman Republican temples that are home to one of the largest and most famous cat colonies in the city. Torre Argentina is known for containing the spot where Julius Caesar was murdered. The ruins have been closed to the public since their discovery in 1926, viewable only from a railing at street level, but in 2023 the city opened the site to visitors. Now you can pay a small fee and descend into the ruins, exploring the site via a raised sidewalk that hovers over the grounds. This is great news for cat lovers because you can get closer to the felines who prowl the site.

Despite the new access, the cats can still be elusive. Spotting them is not always easy but I learned early on that the best way to find cats there is to follow the little girls; they seem to make collecting cat sightings a mission. Often too young to care about the history, they are rightfully fascinated by the cats and, while their parents and older siblings talk about the Ides of March, their keen eyes are scanning every inch of grass and stone for tails and ears. I watched one girl try *so* hard to get a cat to come to her, her focus so intense she was almost vibrating, but the cat just stared at her. These cats have no interest in pleasing people but when they do feel like getting attention, they come up onto the sidewalks and let people pet them.

Underneath the street at Torre Argentina, there is a cat sanctuary that is open to the public a few hours every day. Inside a tiny, low-ceilinged duo of rooms, the cats that are incapable of living on their own outside lounge on cat trees and greet visitors. The two ladies who run the sanctuary are always rushed off their feet trying to care for the colony and deal with the constant flow of tourists. Torre Argentina has over 130 cats. Every cat that is accepted into the fold is vaccinated, tested for feline HIV, and spayed or neutered, but, despite sterilization, the number of cats continues to grow because of abandonment.

The fact is that all of Rome's cat colonies exist and never completely die out because new cats are always abandoned there. It's hard to even get an exact number of residents for the very largest cat colony in Rome, that of the Verano Monumental Cemetery. The grounds there served as a public burial ground in Rome for twenty centuries, though the modern version of the cemetery was not founded until the early nineteenth century. Verano is enormous, more than two hundred sprawling

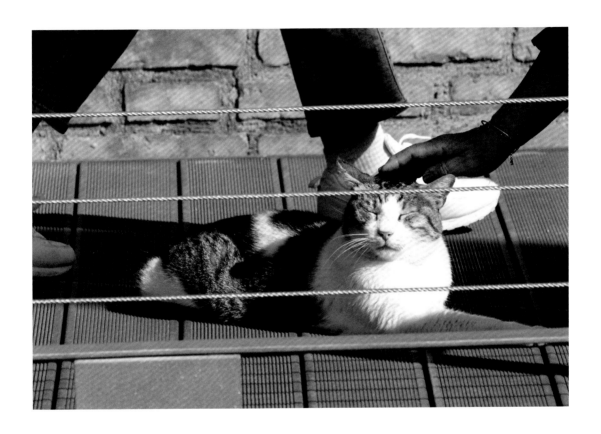

acres of gardens and graves. The cats are believed to be guardians of the dead, protecting the graves.

My first visit to Verano was on a hot day. I was tired and had taken several buses and an Uber to get there on time to meet a gattara from the colony, but somehow we missed each other. I trudged, barely lifting my feet, deflated by the missed connection, though I suspected that I had somehow been in the wrong place, or that the details had been muddled in translation. Since I was there, I felt compelled to walk around. What you can reach on foot in ten or even fifteen minutes in Verano is a fraction of the whole. These graves get all the eyes on them while thousands stack up on the hills behind. I snapped a few photos of exceptionally lovely headstones and then sat down, hoping that a cat might reveal itself, but none did.

The snapshots I took that day ended up being the only proof I had to offer to the angry gattara, who claimed that I had intentionally stood her up. She sent me an email that translated to something like "Don't mess with Romans, we don't give second chances," and, true to her word, she didn't, so I was left to try and navigate Verano on my own.

On my next visit I told myself to just wander without direction or purpose, but I found that my anxiety made me stay near a main road so I wouldn't be swallowed by the rambling graveyard with no address other than that of the main gate. I weaved in an out of plots, enjoying the quiet beauty. Many of the graves have a tiny gas lamp at their helm. I would love to be there at night to see them lit, little candles in the dark should the living or the dead need to find their way.

After two hours of deliberately random exploration, I had still not seen a cat and began to head back toward the main gate exit. There is no shade in the front part of the cemetery, but it was cloudy that day, so I kept to the main path rather than skirting along the edges. About a hundred feet from the exit, I heard a loud meow. I stopped, thinking I was imagining it. But then there it was again. MEOWWWW. A cat! My eyes darted around. I thought that I would have to seek this animal out, but then I spotted a gray tabby sitting on a grave not twenty feet from me, staring very intently at me. MEOWWWW. She was talking to me. The sparkling serendipity that I felt at the sight of her filled me up, transforming my sweaty clothes and aching feet into a price I was

willing to pay for success rather than the markers of failure they had been just minutes before.

I fumbled for my camera, so excited to finally see a cat that I could barely steady my hands. I shot a few cursory frames, thinking that the cat would dart away any second, but she stayed put and continued to talk to me. I inched closer and closer to her. When I got about ten feet away, she turned and trotted off, hiding herself badly under the tarp of a small structure. Only half hidden, and I could see her rump and tail. The meows kept coming. I had brought canned cat food with me, so I opened a tin and emptied it near the spot where I had first seen her. Once I backed off, she eagerly emerged, sniffing the air. She was young and lithe, possibly in her first heat, which would explain the talkativeness. After she ate, I was able to photograph her. I followed her as she wound her way through the graves.

I saw this same cat again at a later visit and she was still alone. My guess is that she was a recent arrival and had either been abandoned there or found her way there from the surrounding streets. I hope that by now she has joined one of the many sub-colonies that live spread out at more than thirty feeding stations around the grounds.

During my time in Rome I photographed eight colonies, chosen for their size, prominence, and accessibility, but there are literally thousands more. I could visit a new colony every single day for ten years and not see them all. The cats of Rome are beloved by Romans and the world, and as much as I want them to always be there, I also hope that their number continues to decline. The cats are there either because they were born feral or are abandoned pets. Those with gattaras to care for them live decent lives in the mild Mediterranean climate. They are fed, vaccinated, and have both human and feline company, but they are still vulnerable to the dangers of living in a huge city, and many bear the scars of it. In Rome, change is loud and constant and seems to swirl around the famous ruins that stand stock-still, witness to thousands of years of human triumph and failure. In between the uproar and the unchanging are the cats, the guardians of the Eternal City.

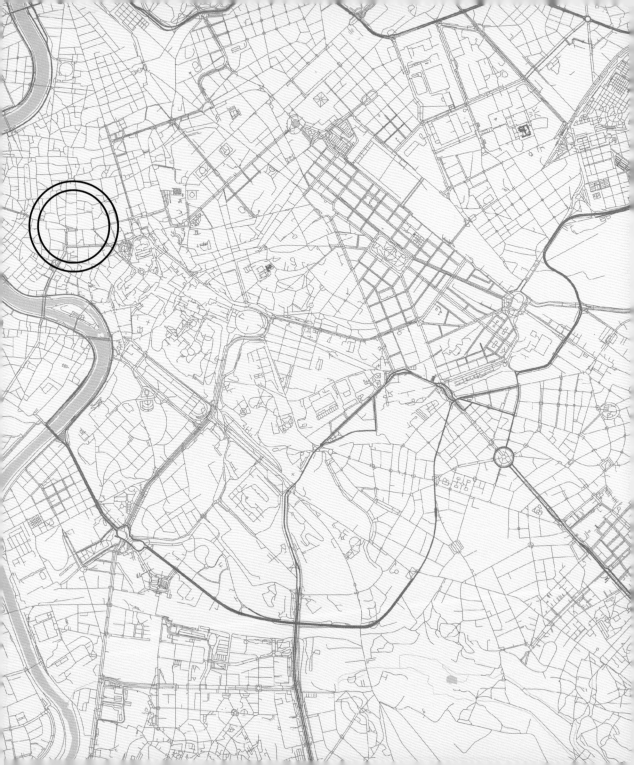

LARGO DI TORRE ARGENTINA

L argo di Torre Argentina is the sacred site of four ancient Roman Republican temples as well as the spot where Julius Caesar was murdered. The ruins were first excavated in 1926, and the sunken, protected nature of the site made it immediately attractive to feral cats, but it wasn't until 1993 that Torre Argentina Cat Sanctuary officially began operating. The immensely popular shelter faces continual threats from archaeological groups that want to evict the cats from the ruins, but so far public support for the cats has won out. Today you can visit and even symbolically adopt the more than 130 felines living in the ancient site and watch as they wander, stretch, yawn, and sniff over two thousand years of history.

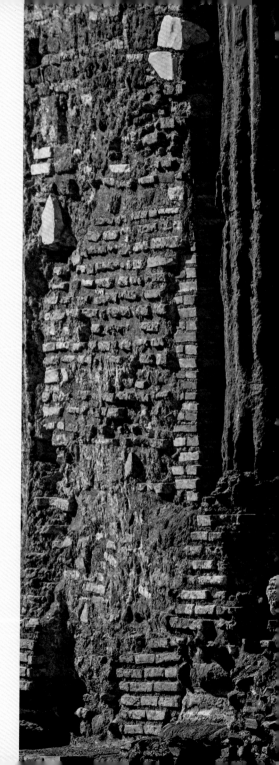

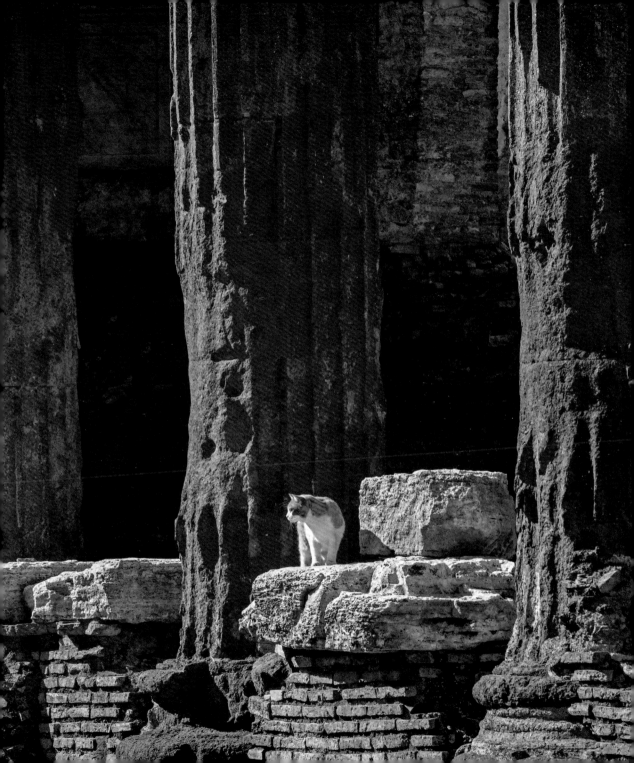

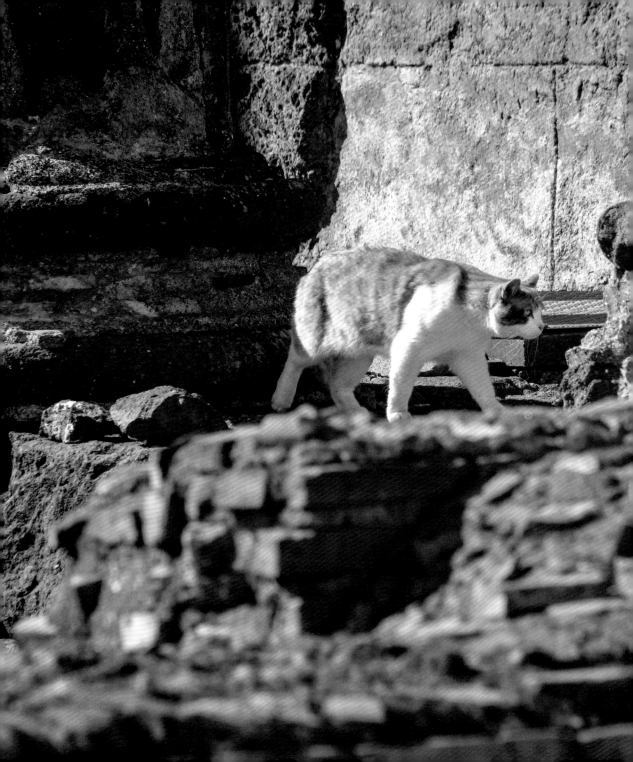

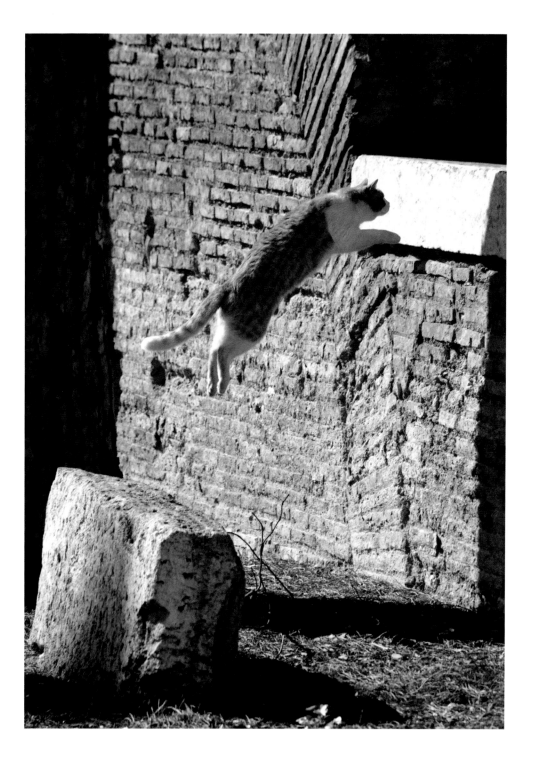

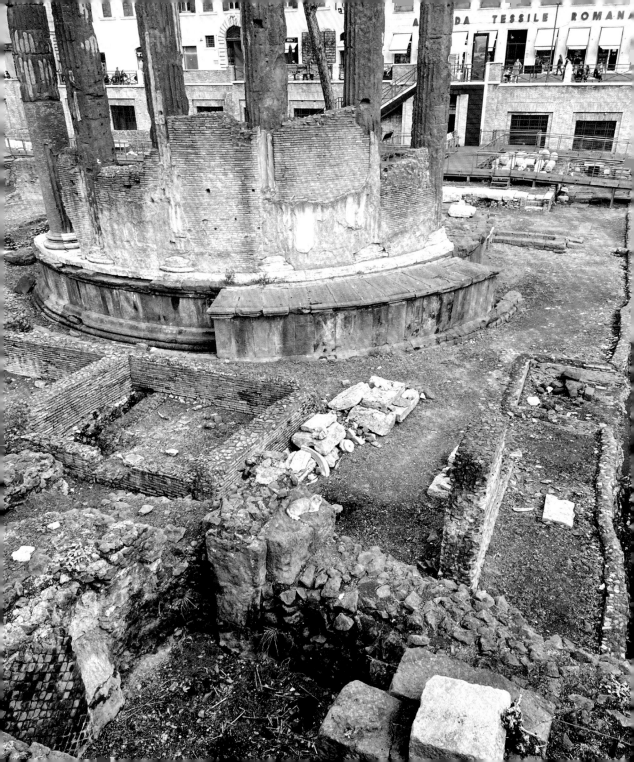

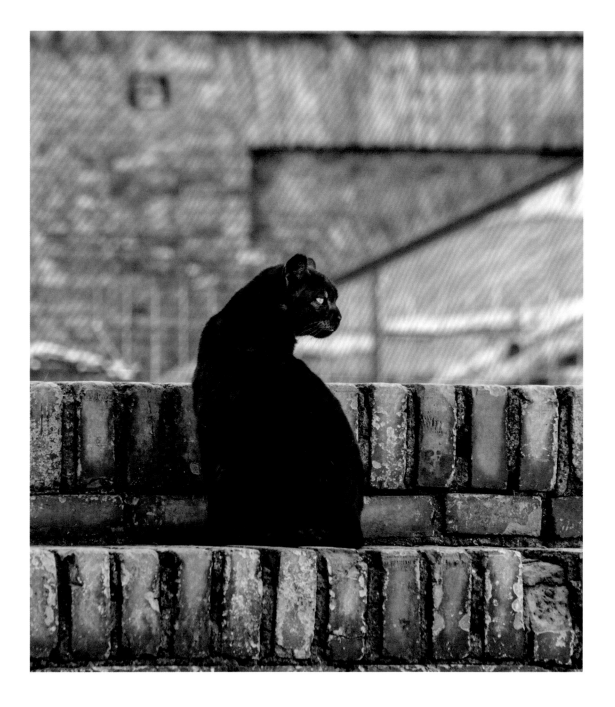

LARGO DI TORRE ARGENTINA

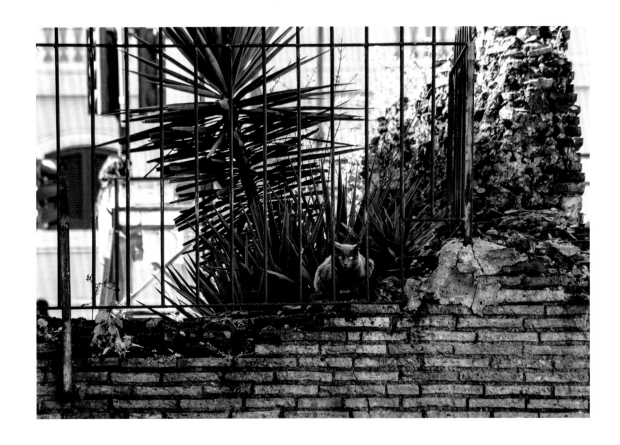

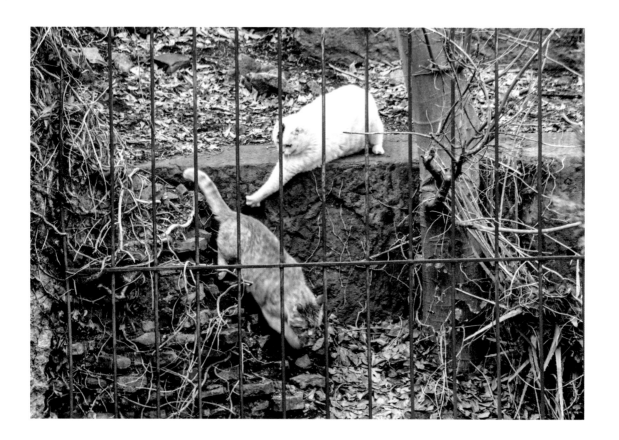

LARGO DI TORRE ARGENTINA

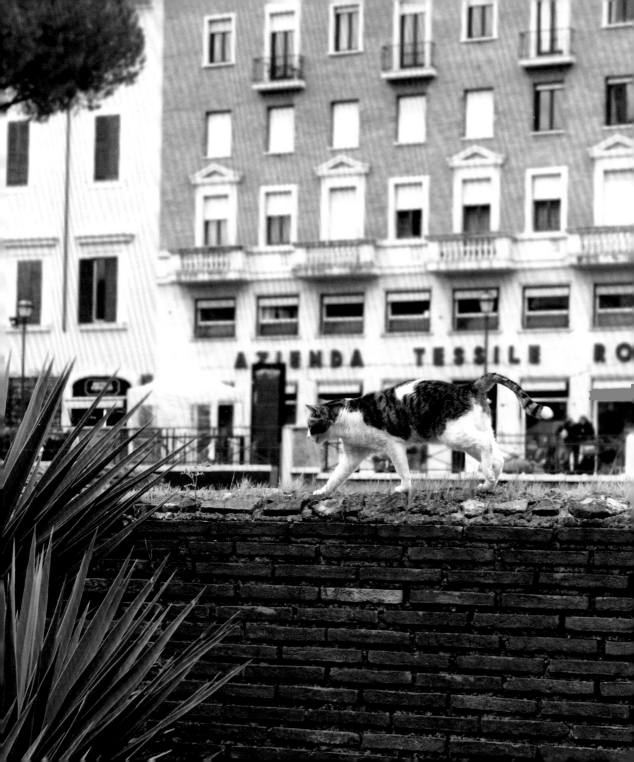

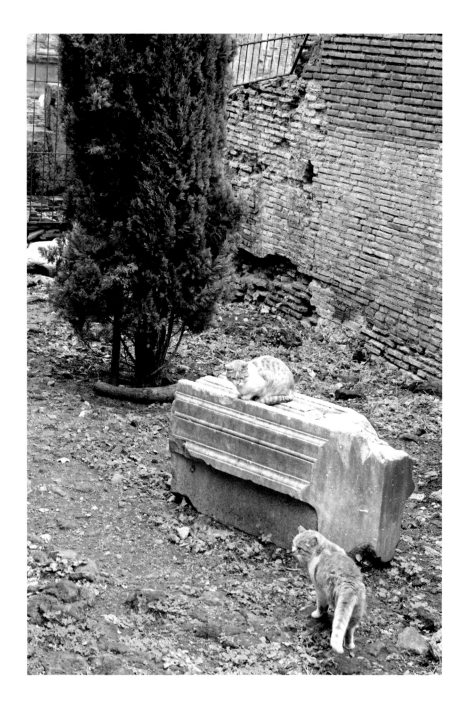

LARGO DI TORRE ARGENTINA

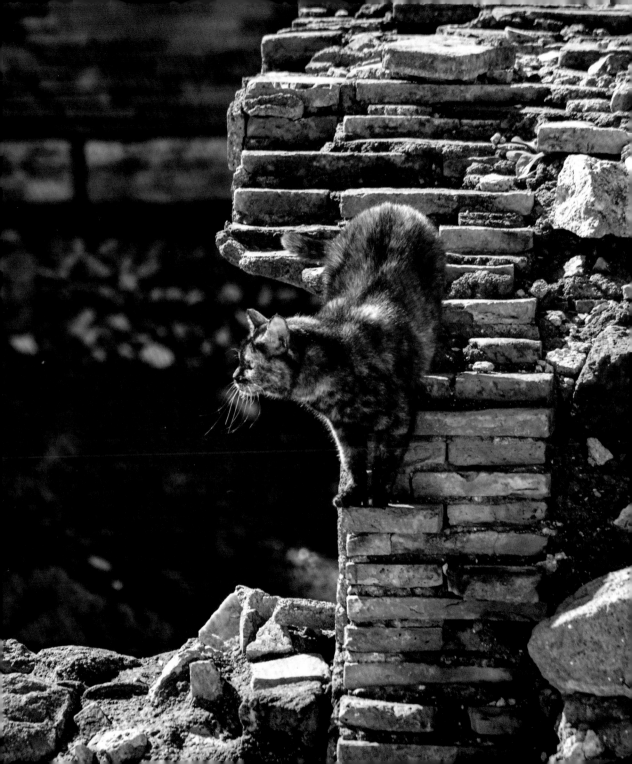

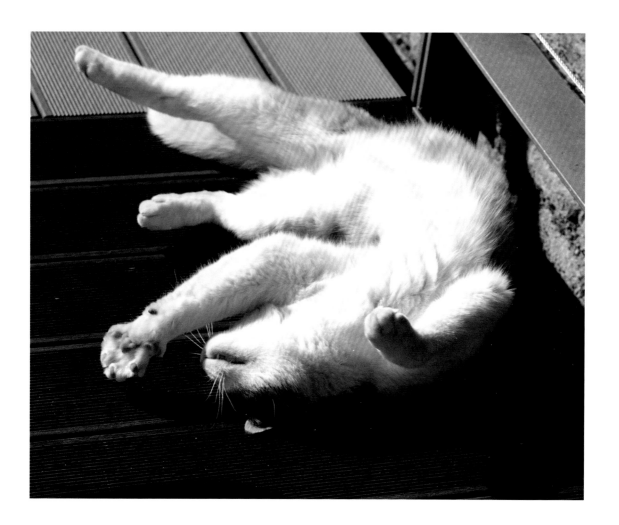

LARGO DI TORRE ARGENTINA

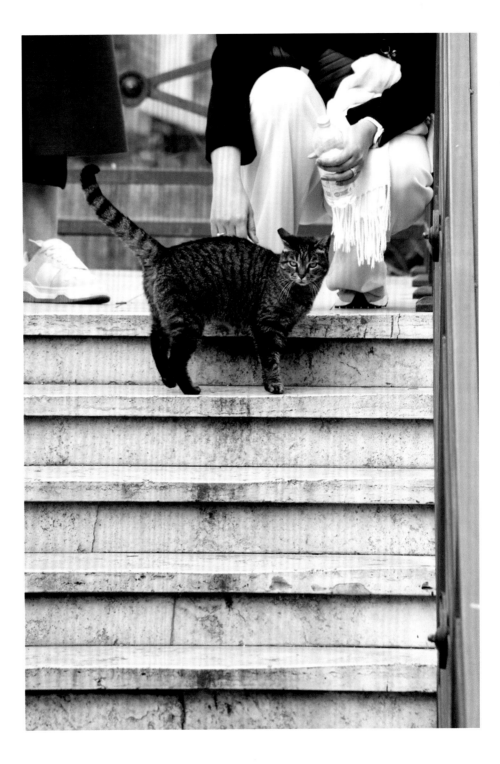

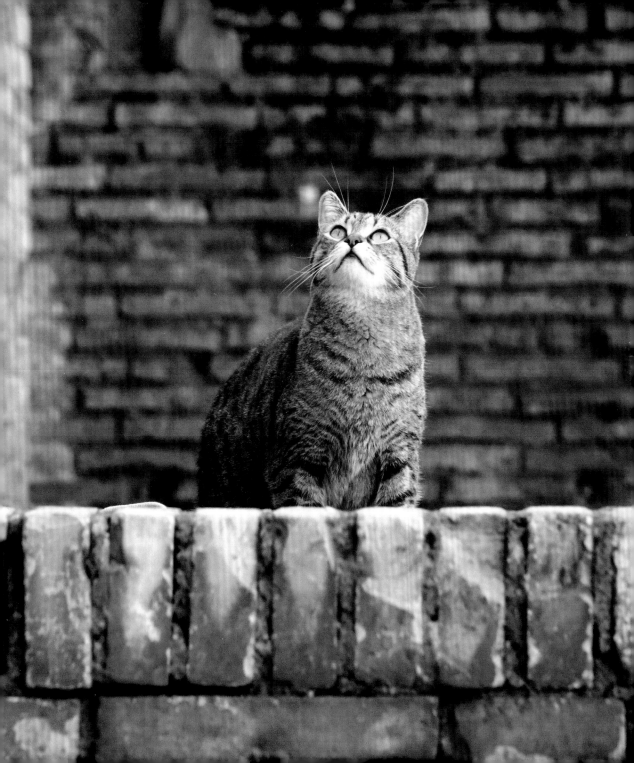

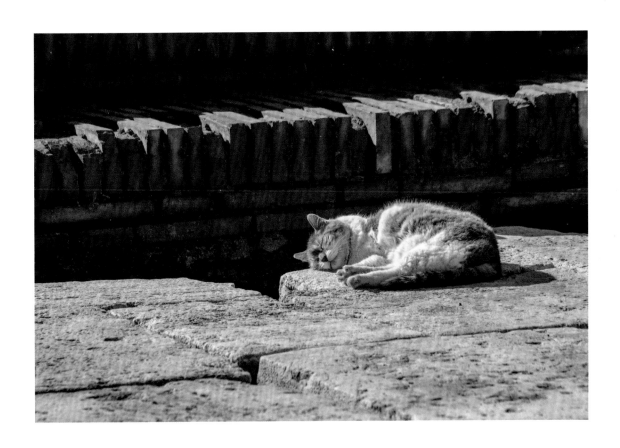

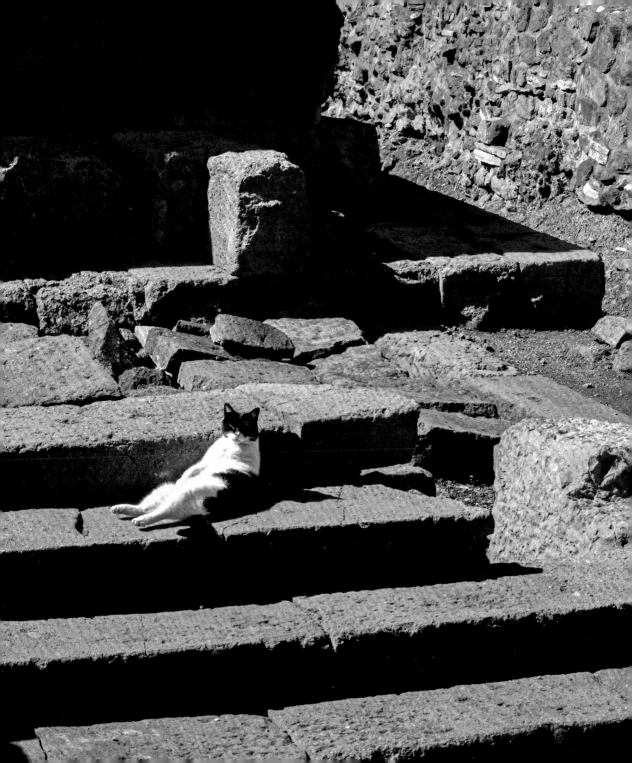

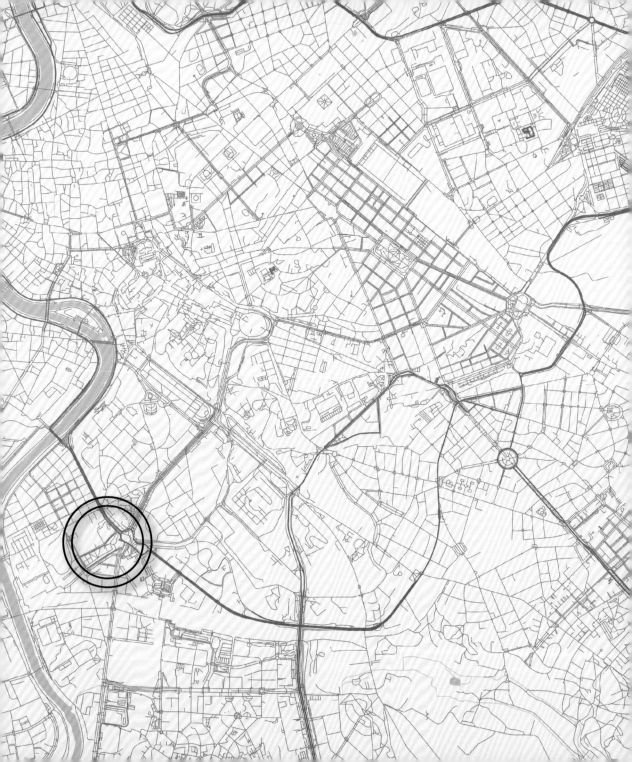

PROTESTANT CEMETERY

B ehind the Pyramid of Cestius is one of Rome's greatest hidden gems, the Protestant Cemetery. Inside the high stone walls are headstones dating to the eighteenth century hugged by a verdant perennial garden. The rows of monuments slope up a gentle hill and are navigated by means of narrow pebble paths that lead visitors through the graves of expats, travelers, dignitaries, and young people who died on their grand tour during the Victorian era. The cemetery is also notably home to the graves of the poets John Keats and Percy Bysshe Shelley, who, by different means, both ended up with Rome as their final resting place. Winding in between the headstones and sauntering down the pebble paths are the cats of the Pyramid colony. Some are exceptionally friendly and invite interaction; others are more aloof, perching atop high monuments, surveying the uniquely beautiful enclave that they guard.

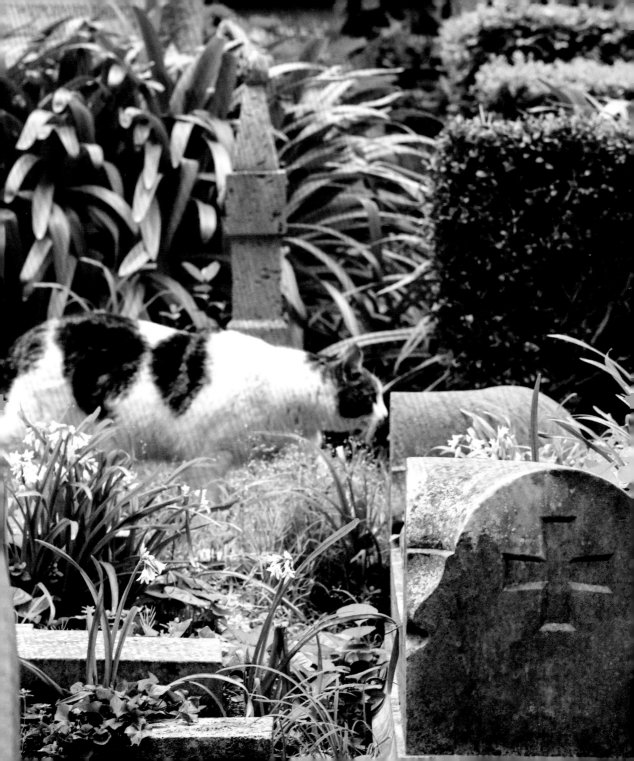

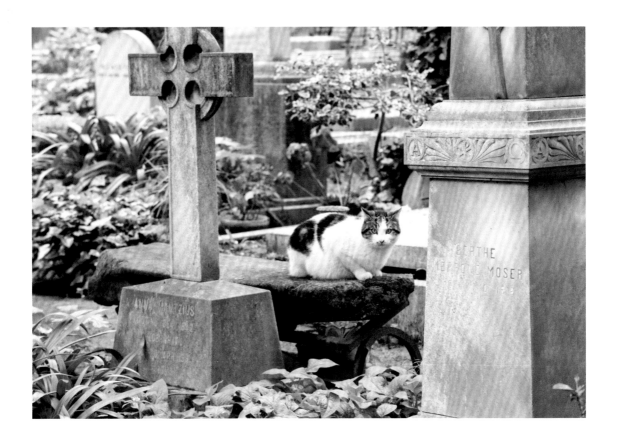

PROTESTANT CEMETERY

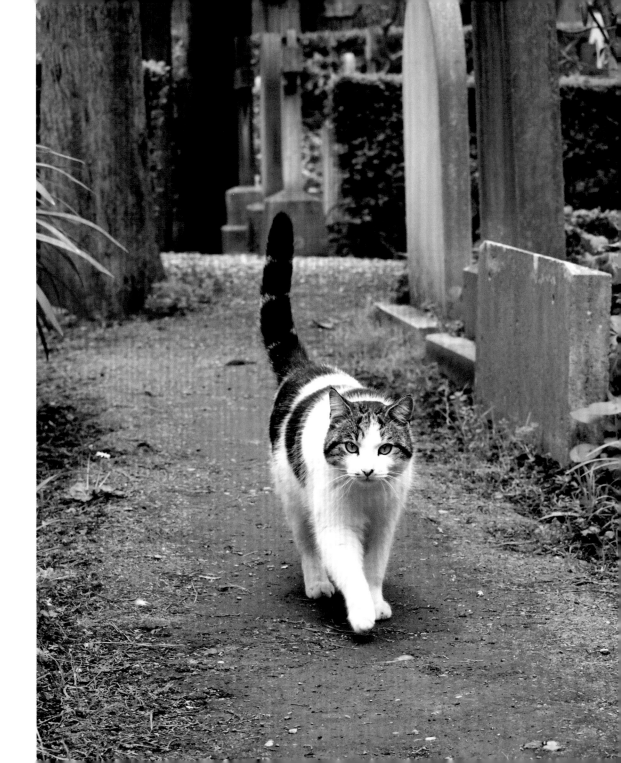

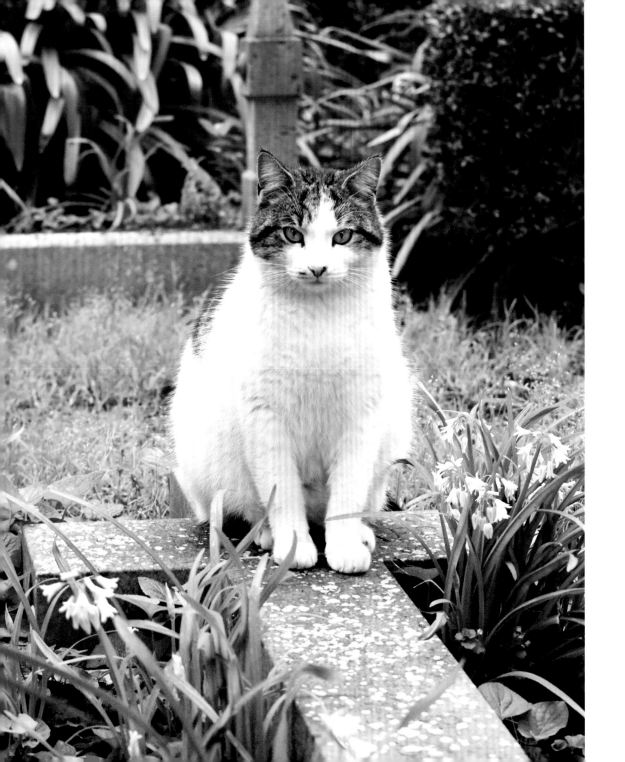

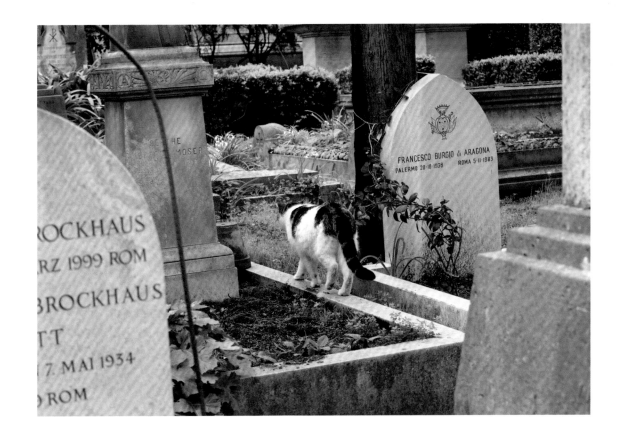

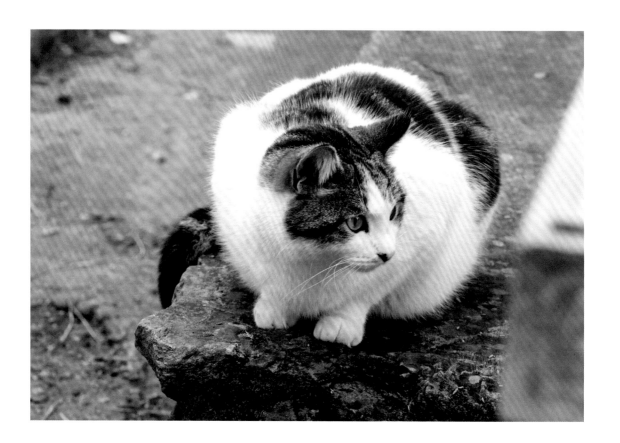

PROTESTANT CEMETERY

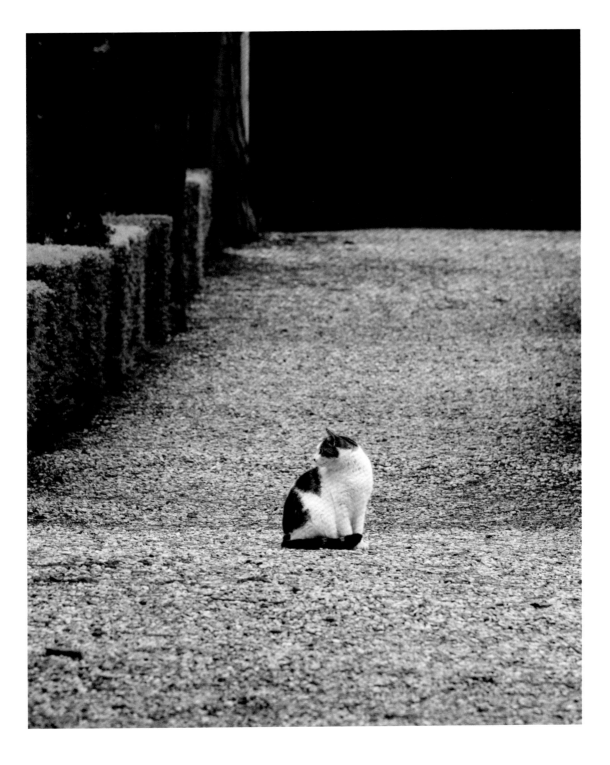

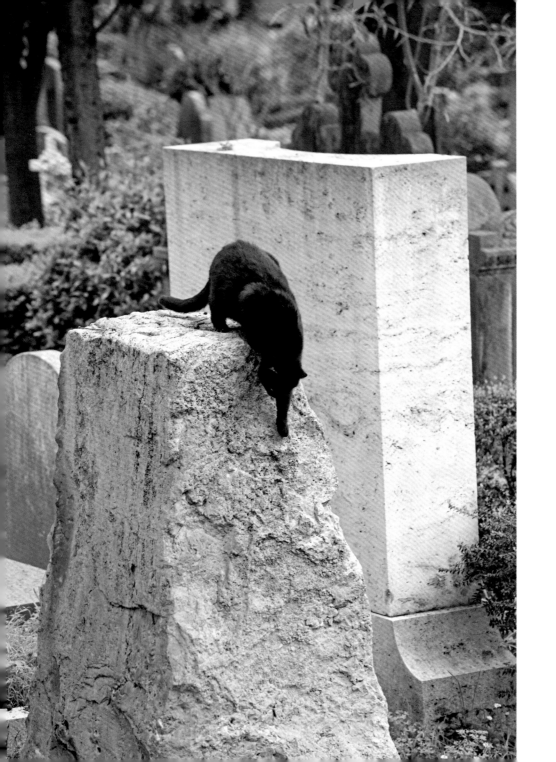

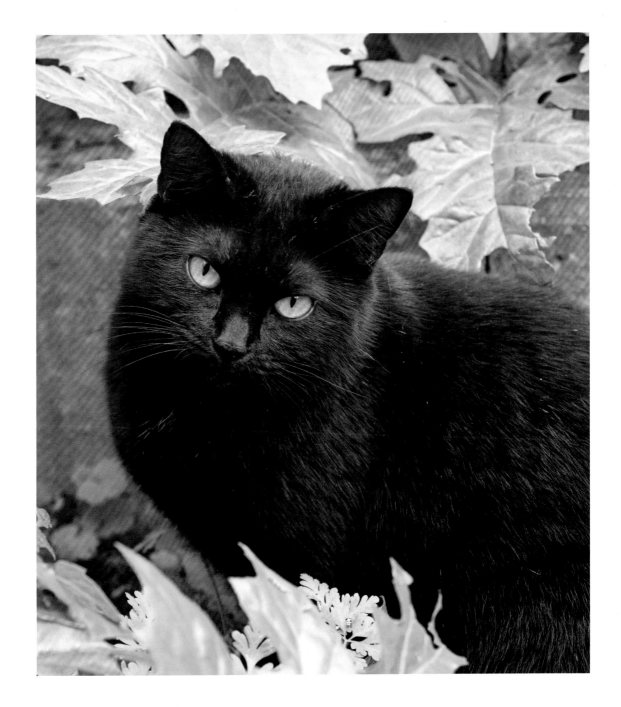

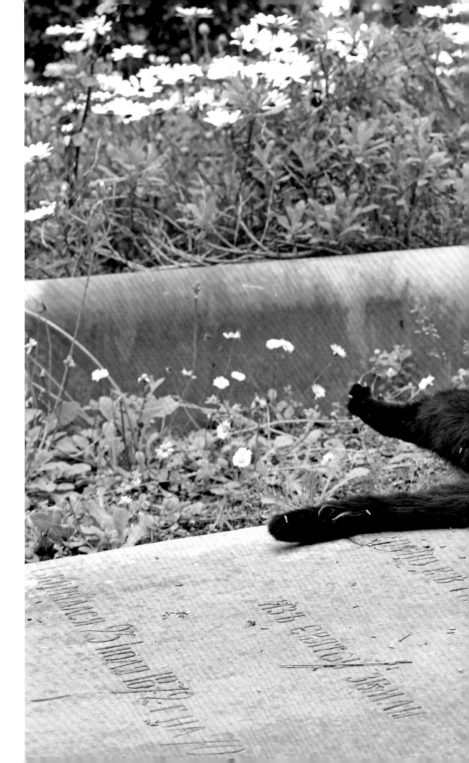

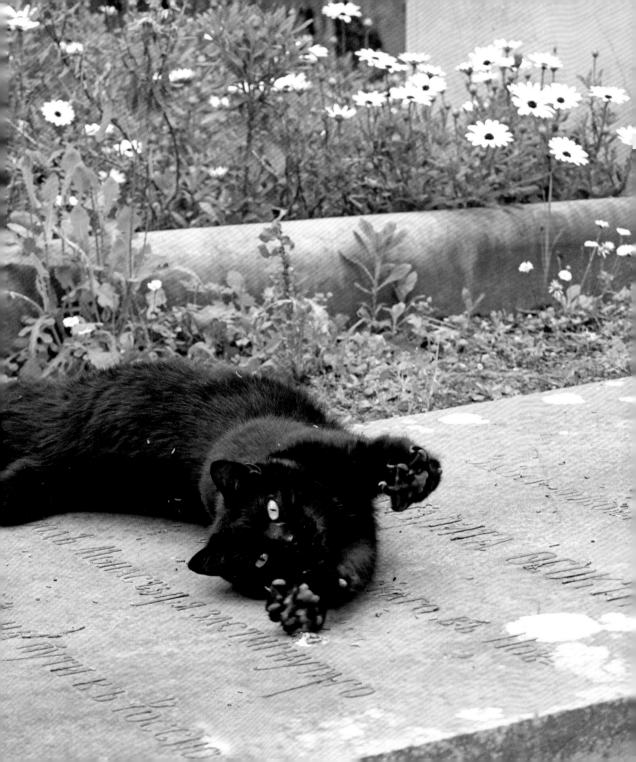

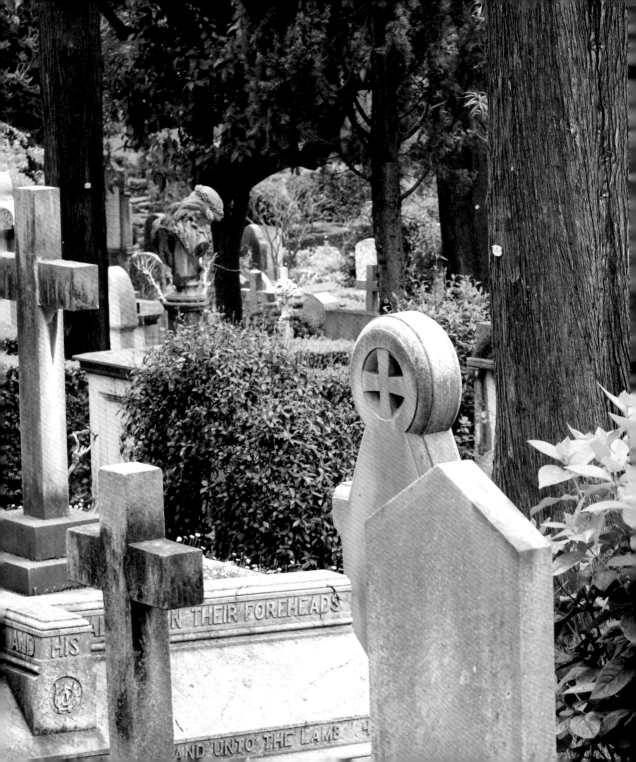

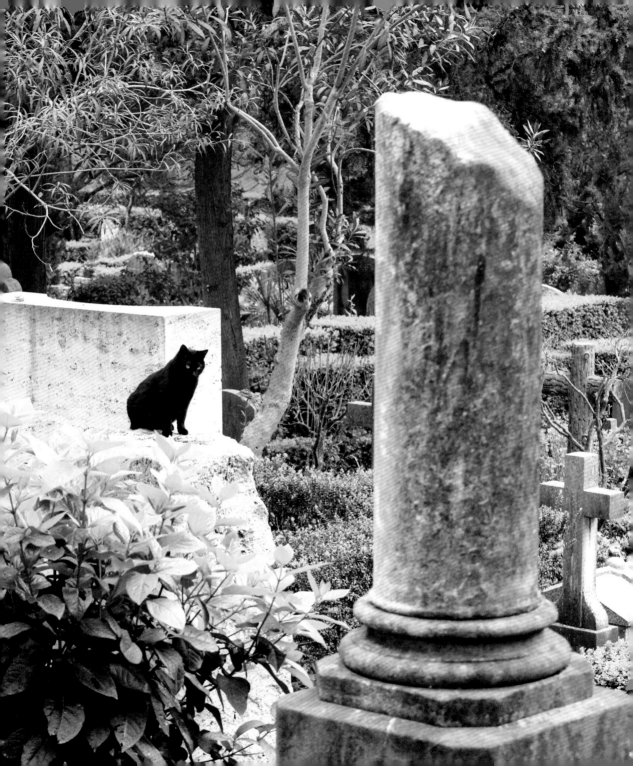

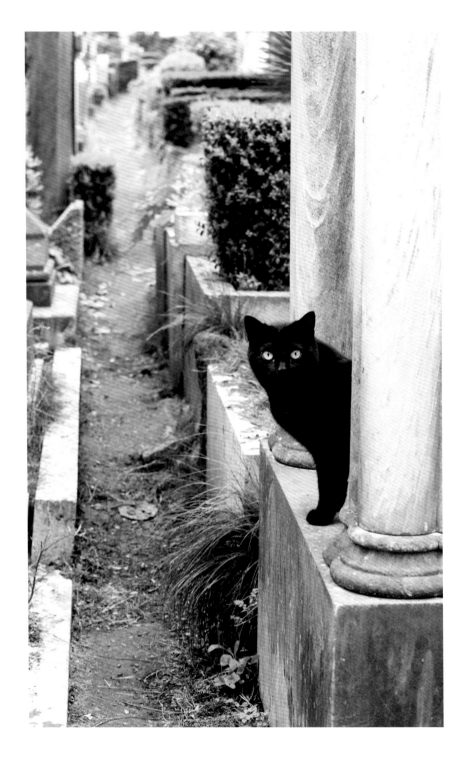

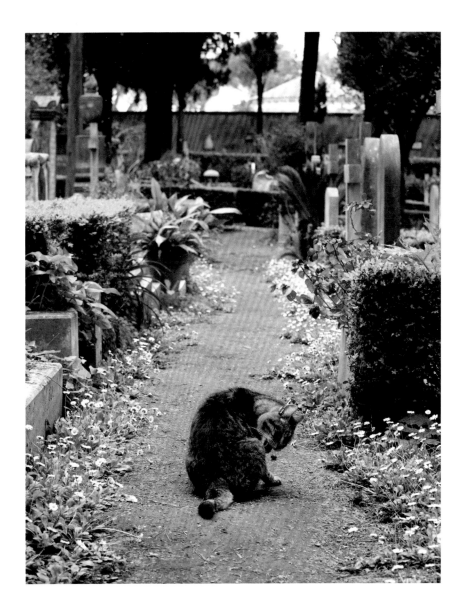

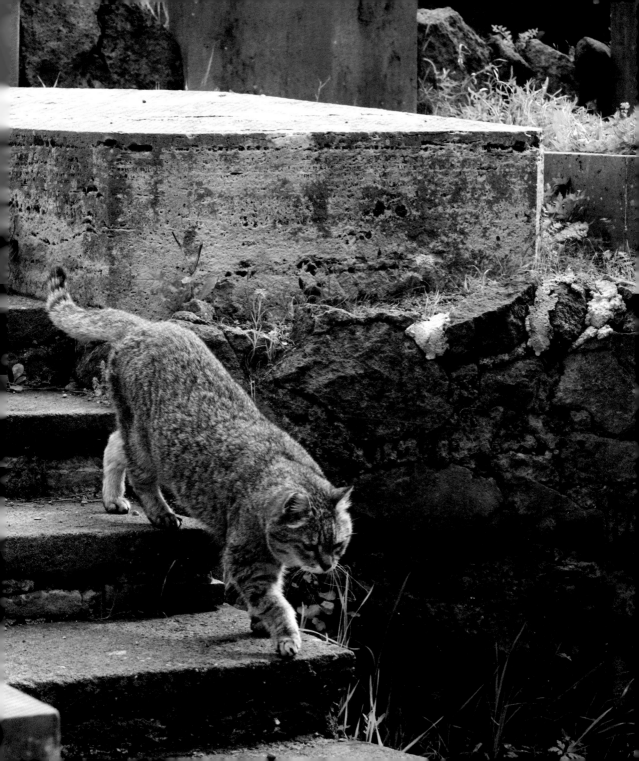

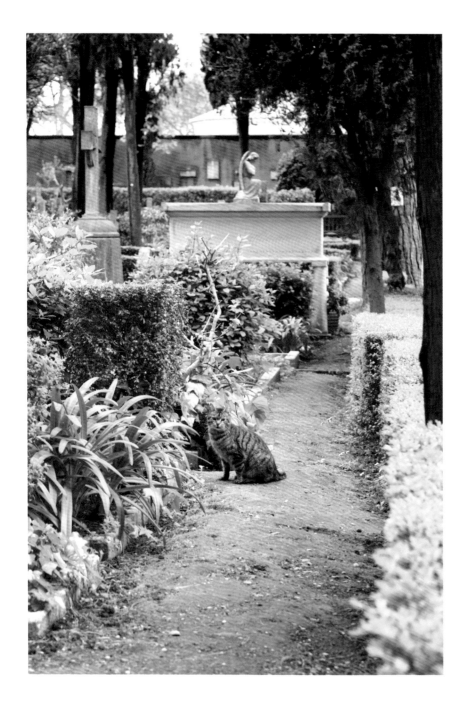

PROTESTANT CEMETERY

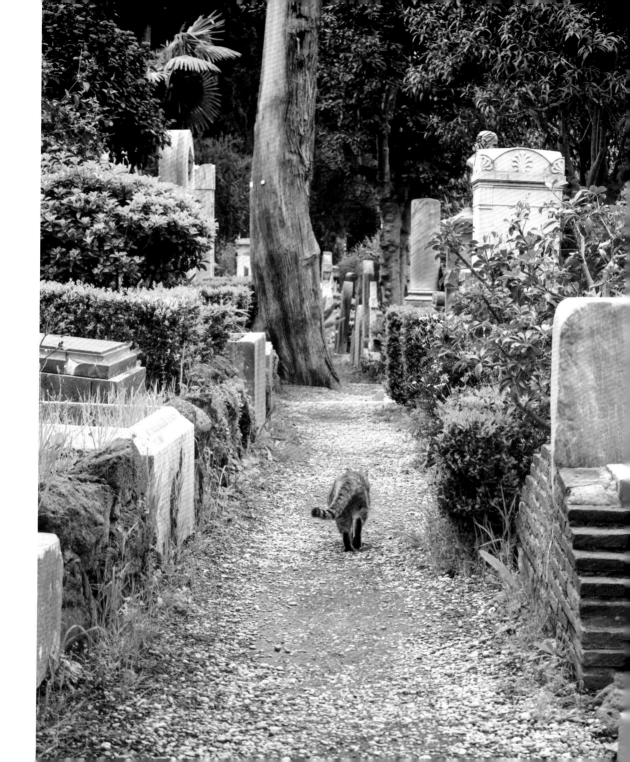

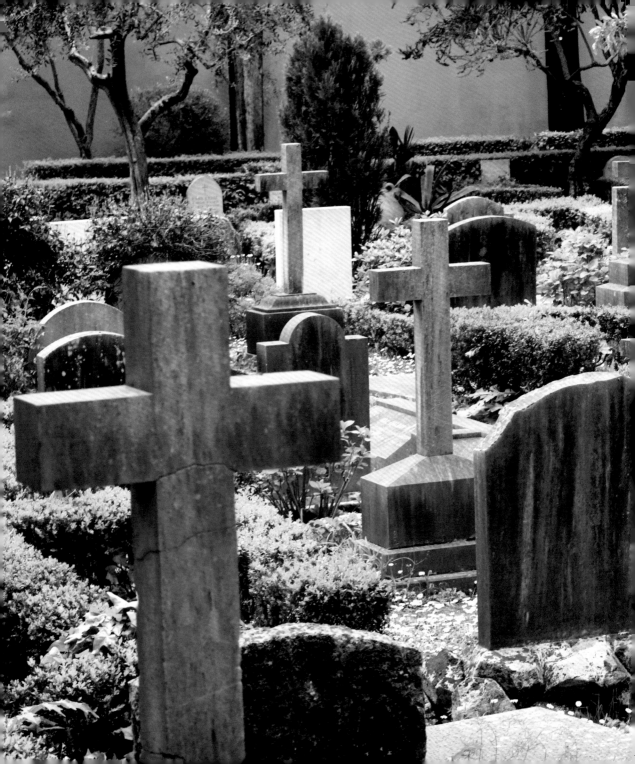

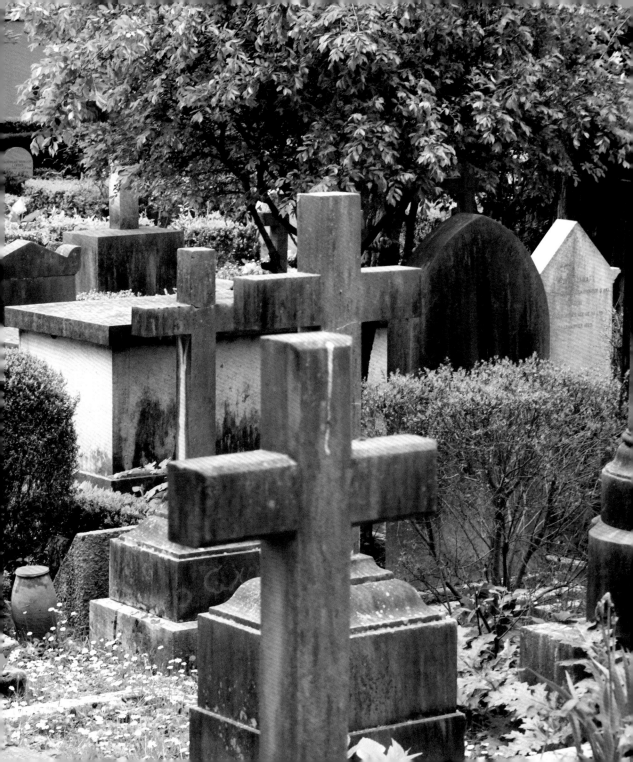

PORTA MAGICA

Porta Magica is an alchemical monument that lies behind iron gates in a corner of Piazza Vittorio Emanuele II, along with the massive remains of an ancient Roman fountain dating to the third century AD. About thirty cats inhabit the ruins and grounds around Porta Magica. The piazza is the largest in Rome and full of activity, which the cats watch almost as intently as they watch the pigeons who like to perch high up on the ruins. The fountain has many levels, tunnels, and nooks, all of which function as a magnificent shelter and playground for the cats.

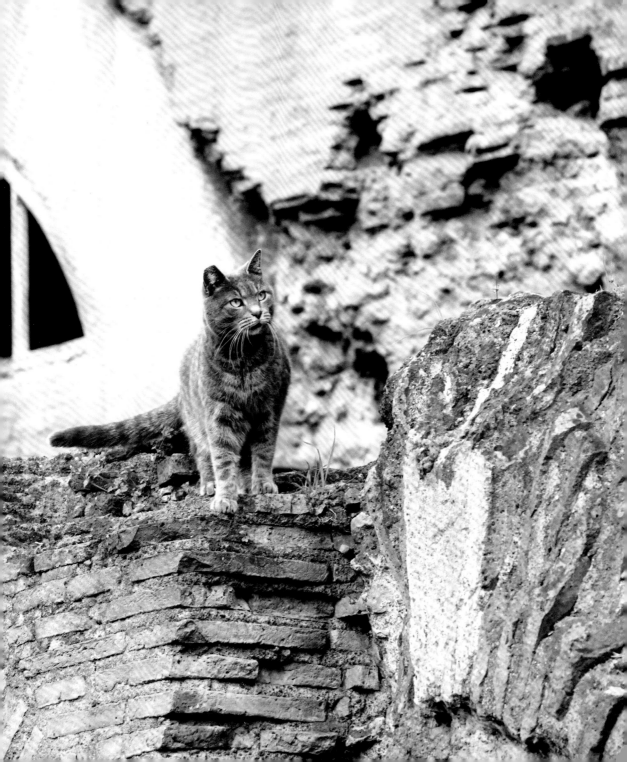

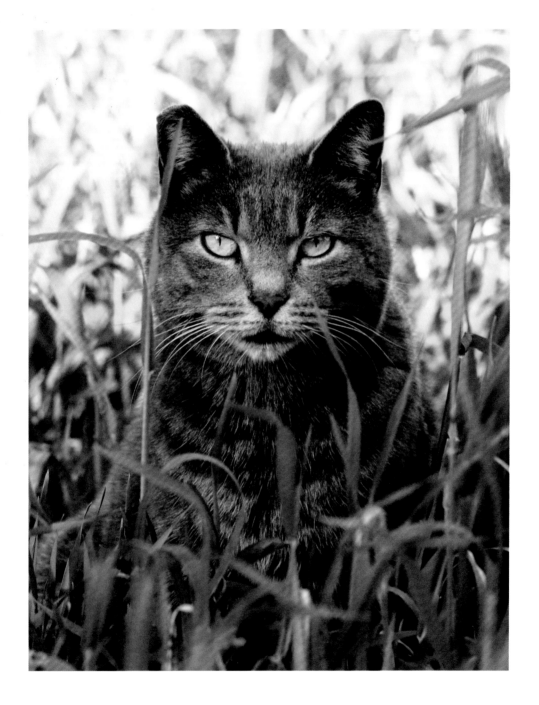

PORTA MAGICA

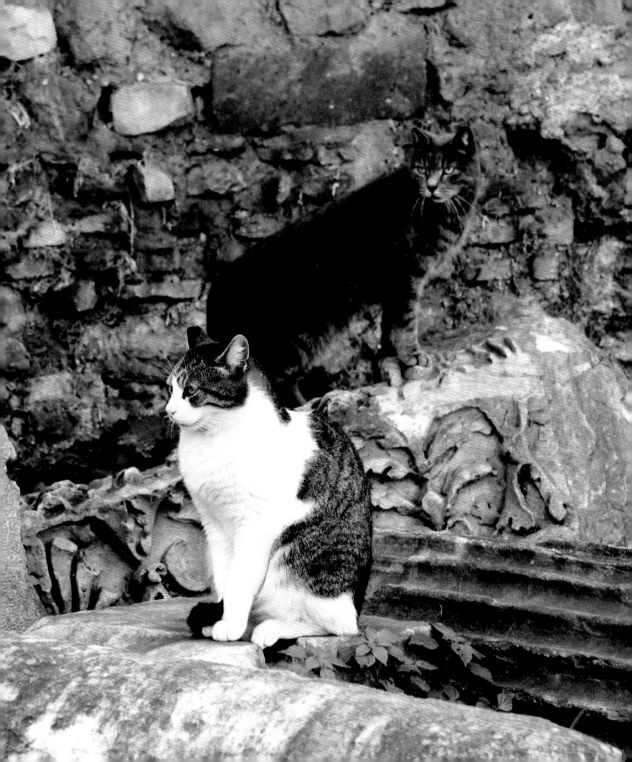

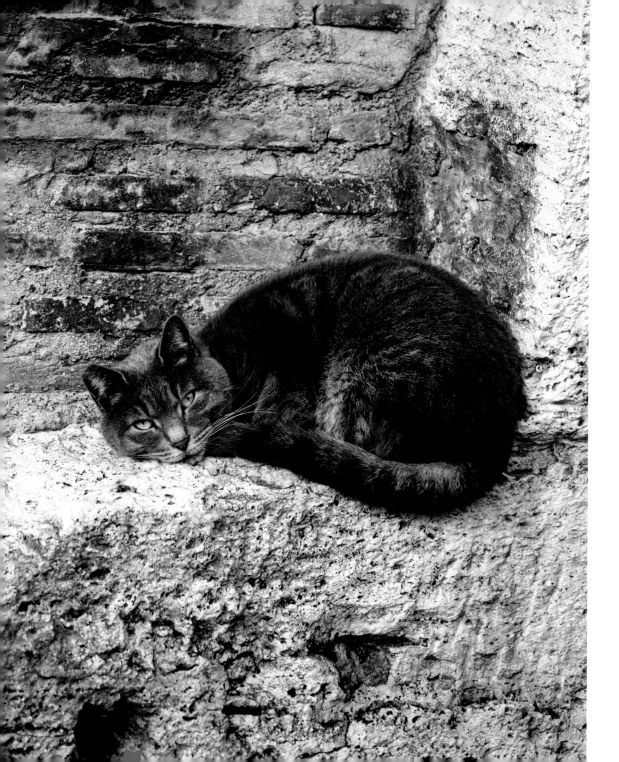

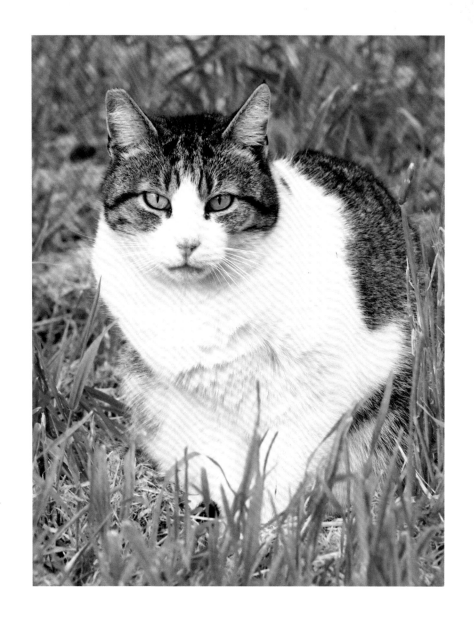

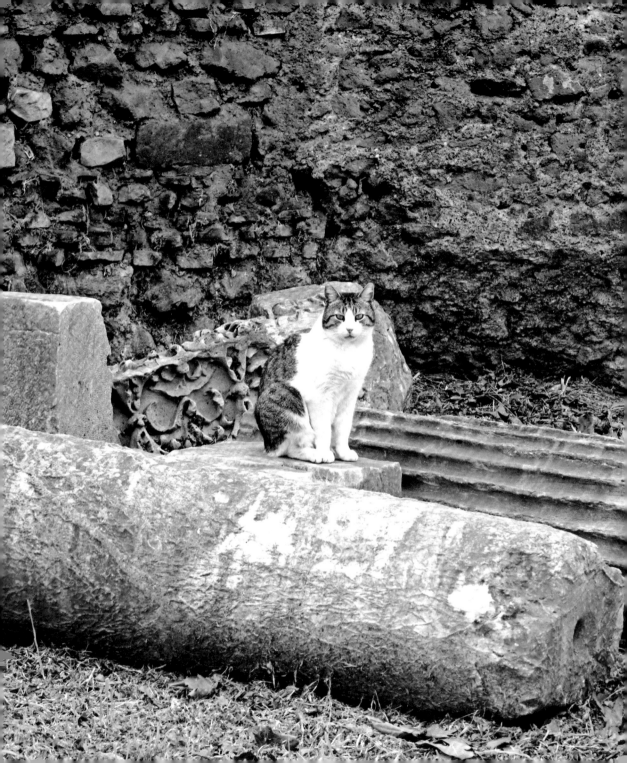

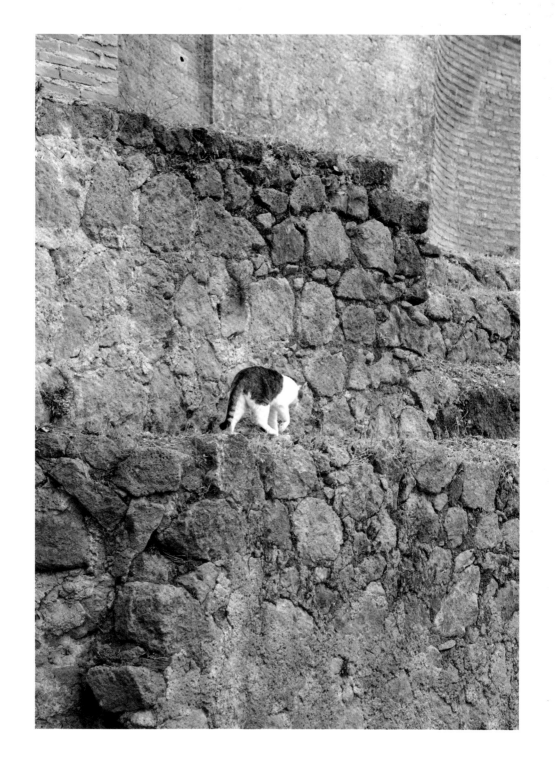

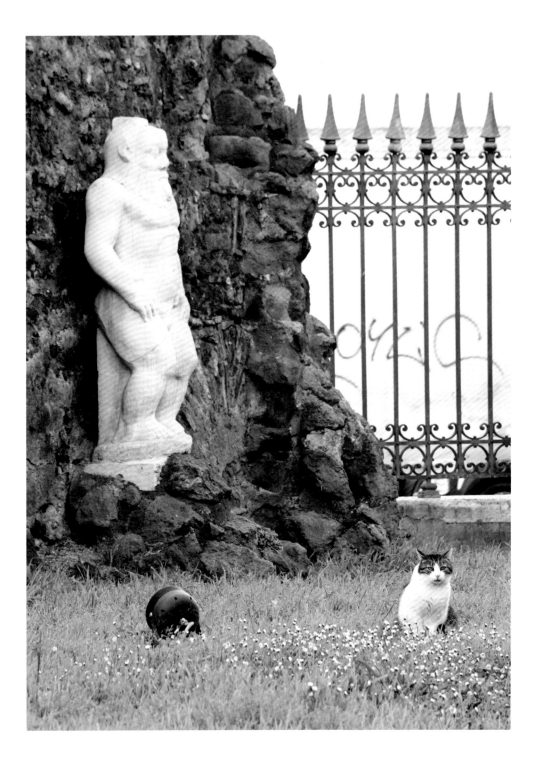

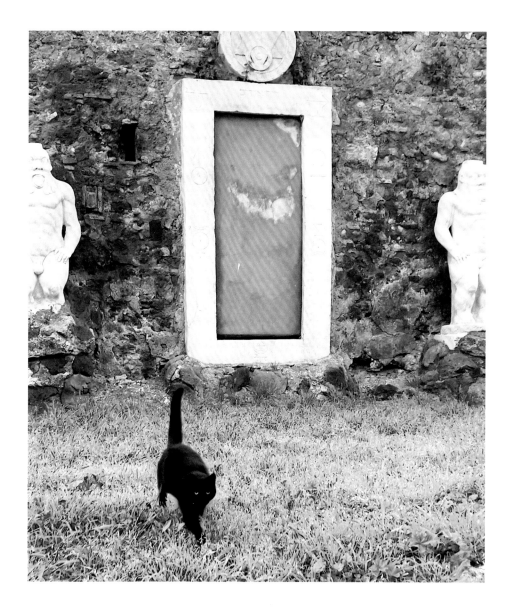

PORTA MAGICA

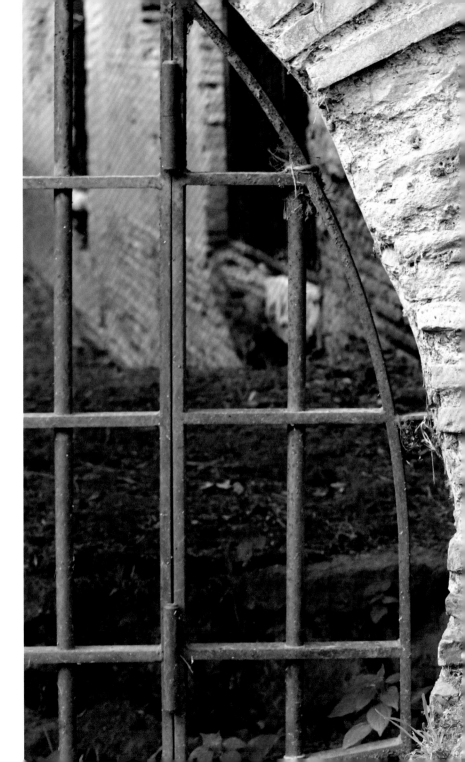

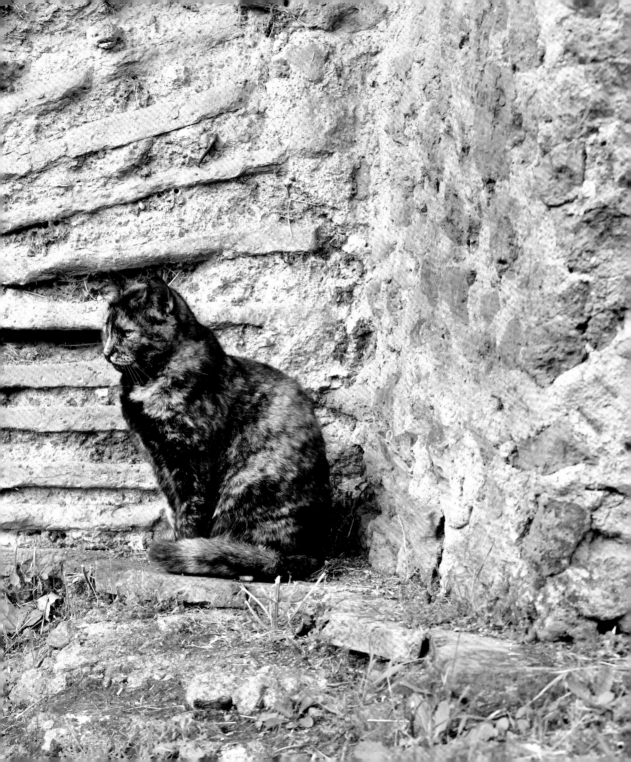

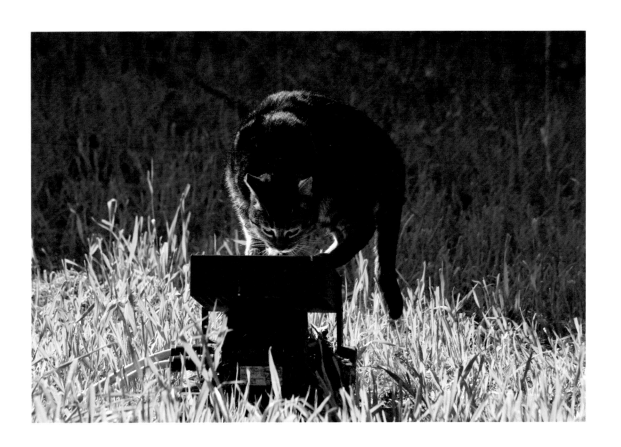

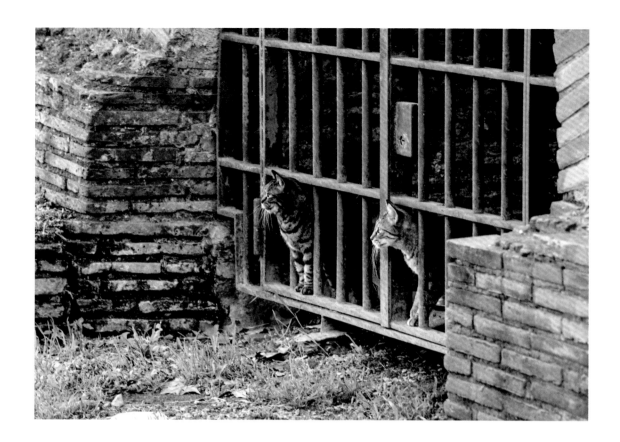

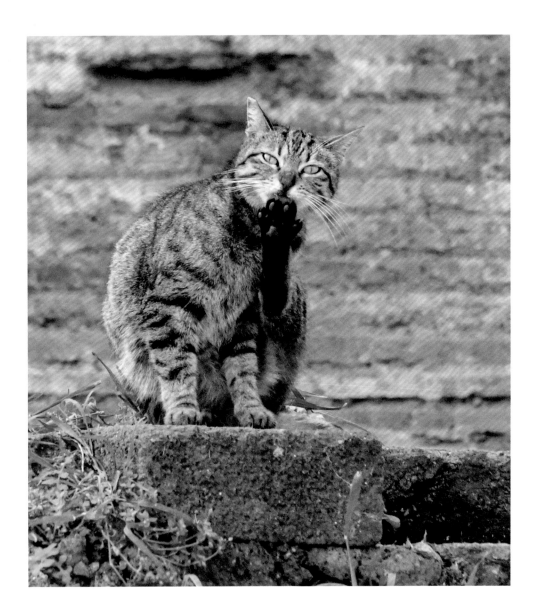

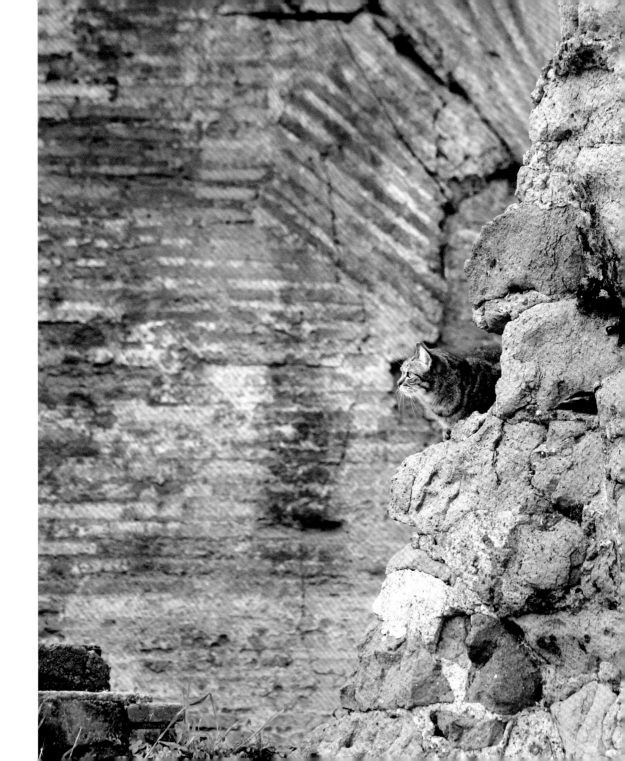

DOMUS AUREA

Across the street from the always bustling Colosseum is Oppian Hill, one of the seven hills of Rome. The steep path leads up to the entrance of the Domus Aurea, a palatial imperial complex built into the hill by Emperor Nero in 64 AD. Now, it is a relatively quiet attraction that showcases what remains of Nero's extravagance. Beneath the tree near the gated entrance to the Domus are folded blankets and plastic bowls heaped with dry cat food. A sign on the iron fence declares this to be the official home of a cat colony. As with all colonies, the cats are free to roam. Most spend their time in the surrounding park with its tall grasses, sloping hills, and plentiful rodents. A few are fond of sitting on the warm hoods of employees' cars and occasionally a cat might wander down into the cool underground ruins.

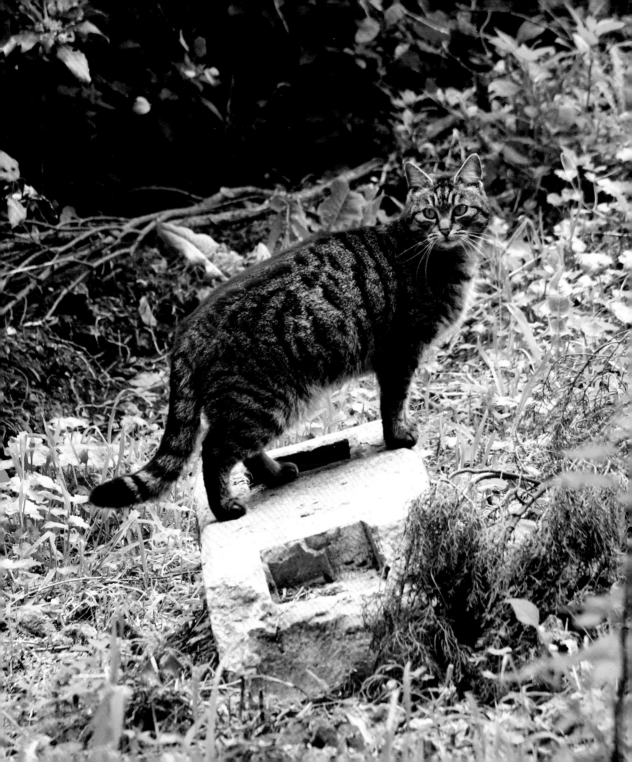

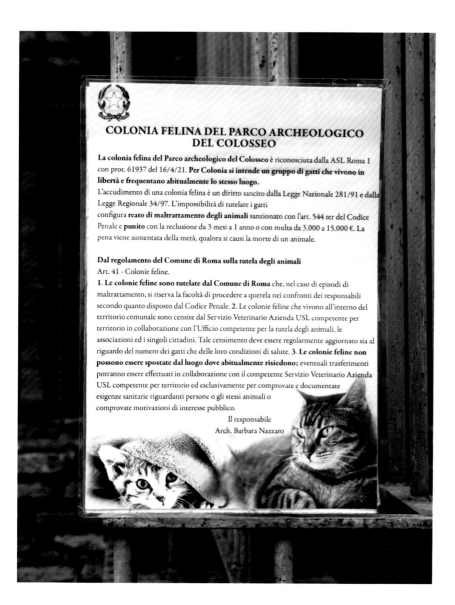

COLONIA FELINA DEL PARCO ARCHEOLOGICO DEL COLOSSEO

La colonia felina del Parco archeologico del Colosseo è riconosciuta dalla ASL Roma 1 con prot. 61937 del 16/4/21. **Per Colonia si intende un gruppo di gatti che vivono in libertà e frequentano abitualmente lo stesso luogo.**

L'accudimento di una colonia felina è un diritto sancito dalla Legge Nazionale 281/91 e dalla Legge Regionale 34/97. L'impossibilità di tutelare i gatti configura **reato di maltrattamento degli animali** sanzionato con l'art. 544 ter del Codice Penale e **punito** con la reclusione da 3 mesi a 1 anno o con multa da 3.000 a 15.000 €. La pena viene aumentata della metà, qualora si causi la morte di un animale.

Dal regolamento del Comune di Roma sulla tutela degli animali
Art. 41 - Colonie feline.
1. Le colonie feline sono tutelate dal Comune di Roma che, nel caso di episodi di maltrattamento, si riserva la facoltà di procedere a querela nei confronti dei responsabili secondo quanto disposto dal Codice Penale. **2.** Le colonie feline che vivono all'interno del territorio comunale sono censite dal Servizio Veterinario Azienda USL competente per territorio in collaborazione con l'Ufficio competente per la tutela degli animali, le associazioni ed i singoli cittadini. Tale censimento deve essere regolarmente aggiornato sia al riguardo del numero dei gatti che delle loro condizioni di salute. **3. Le colonie feline non possono essere spostate dal luogo dove abitualmente risiedono;** eventuali trasferimenti potranno essere effettuati in collaborazione con il competente Servizio Veterinario Azienda USL competente per territorio ed esclusivamente per comprovate e documentate esigenze sanitarie riguardanti persone o gli stessi animali o comprovate motivazioni di interesse pubblico.

Il responsabile
Arch. Barbara Nazzaro

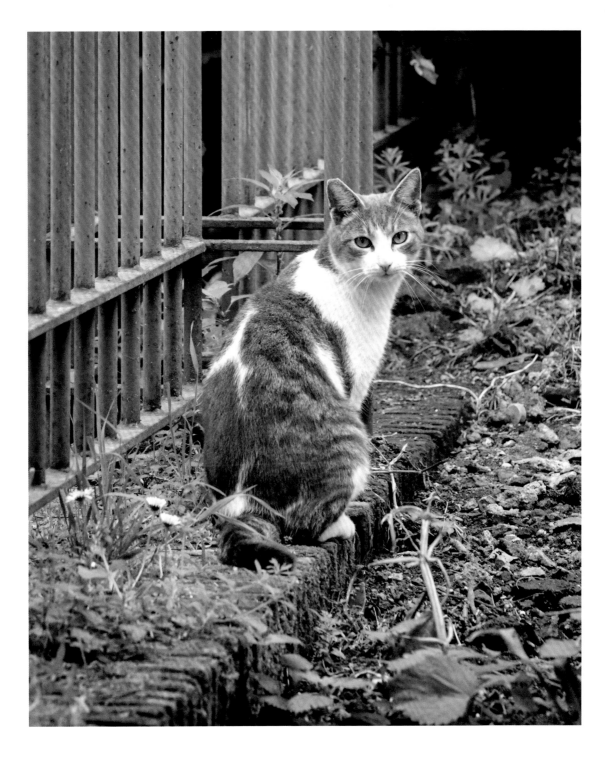

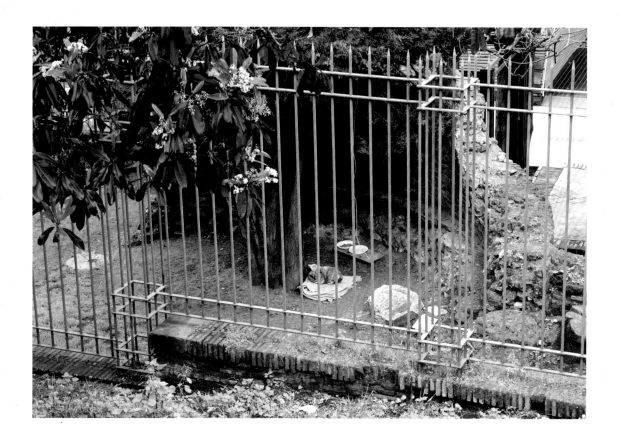

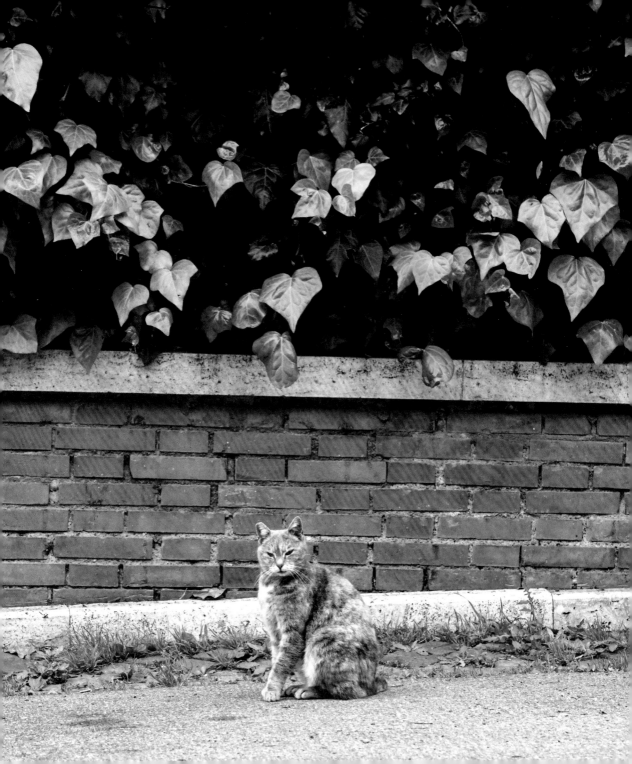

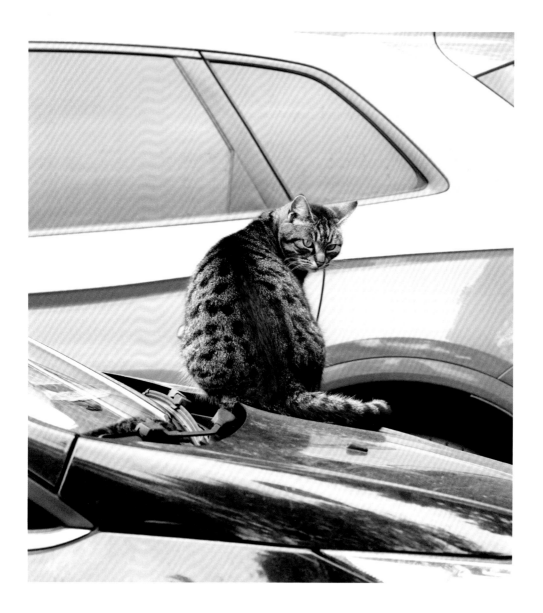

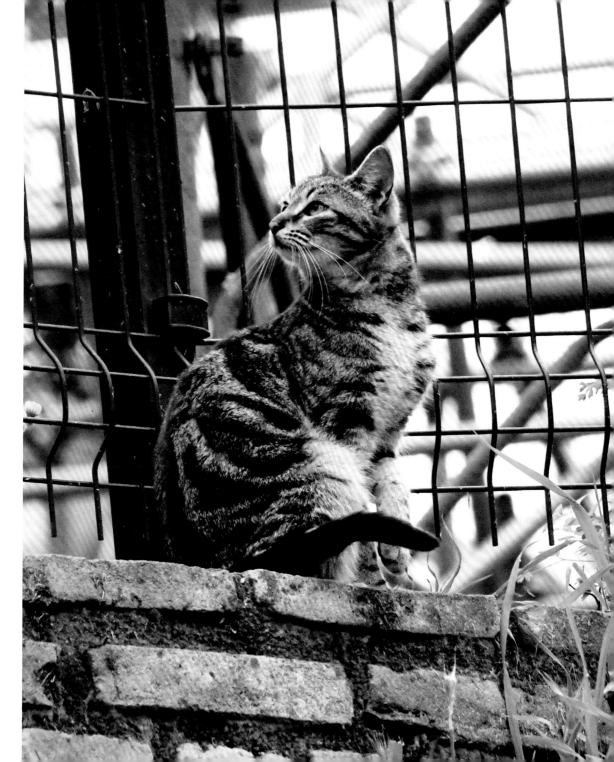

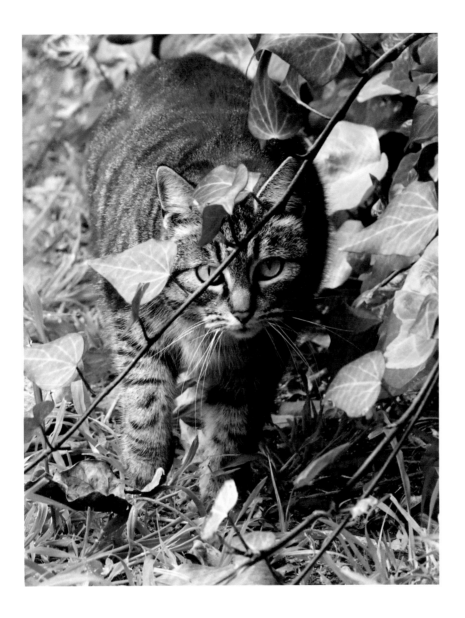

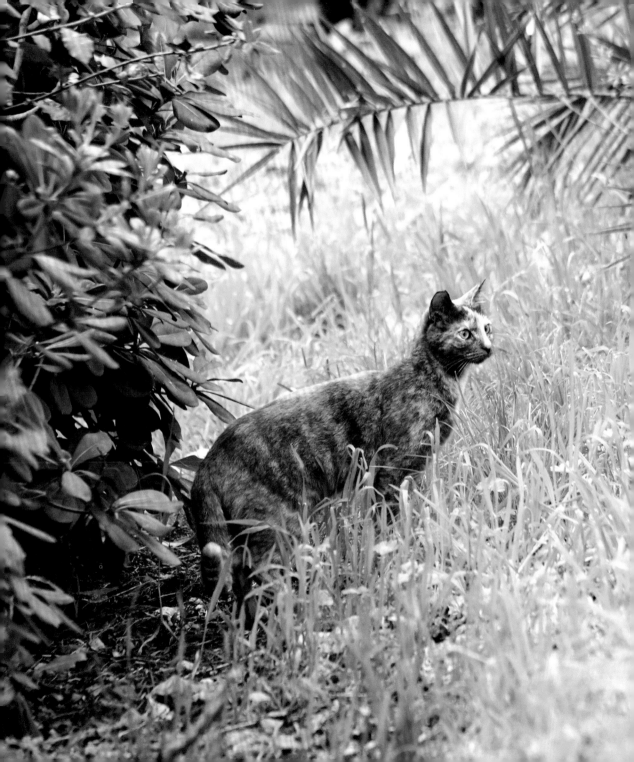

COLOSSEUM

Many generations of Colosseum cats have lived within the ancient walls of this legendary amphi-theater. Listed as one of the Seven Wonders of the World, the Colosseum admits about four million visitors per year; a small fraction of those get to glimpse Augusto, now one of only two cats remaining in the Colosseum. The other, Tigretta, is seen only by employees, and fleetingly at that. The cats here are not technically a colony anymore—they are more like celebrities. Up until quite recently there was a colony living here, but they were moved across the street to Domus Aurea, where there is less vehicle and foot traffic. Now elderly Augusto is the only visible permanent resident.

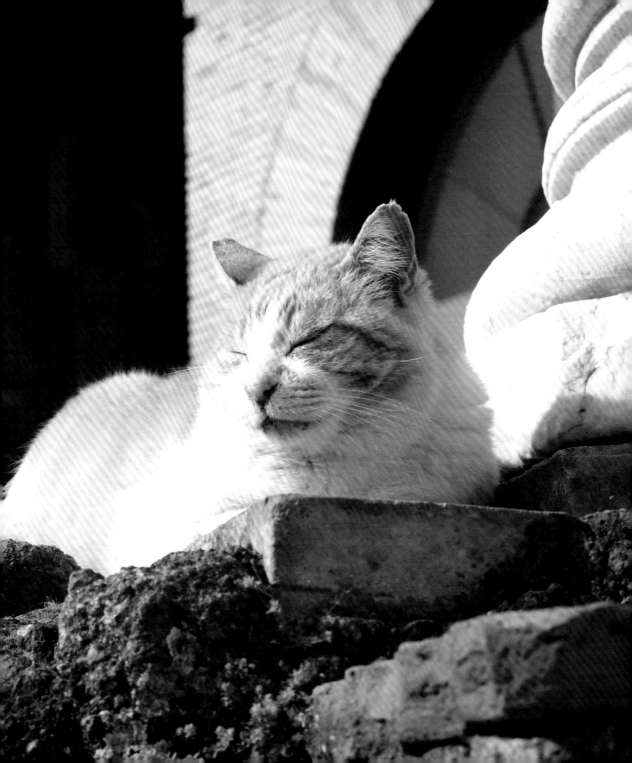

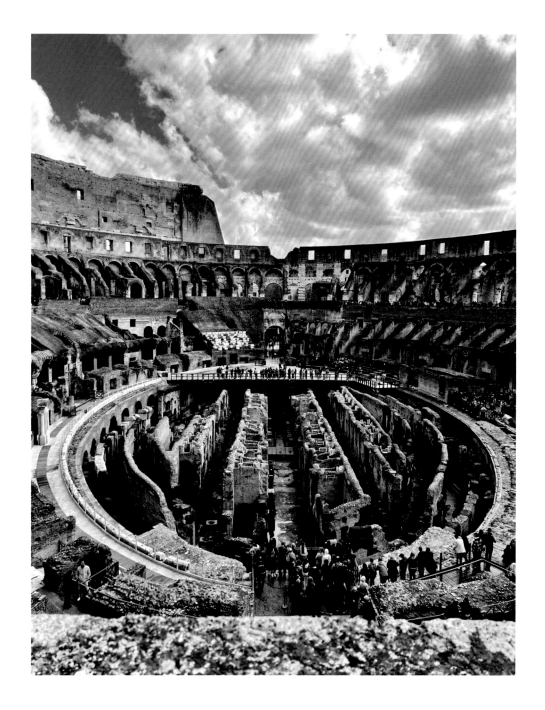

COLOSSEUM

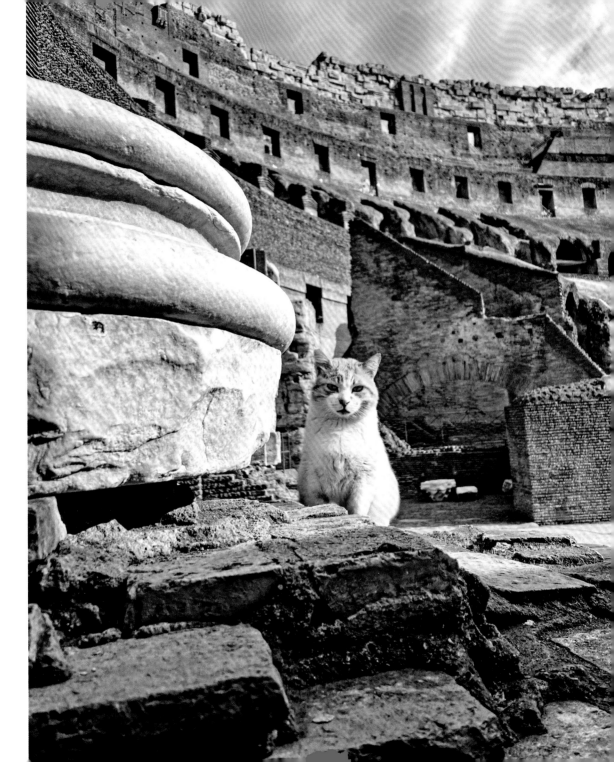

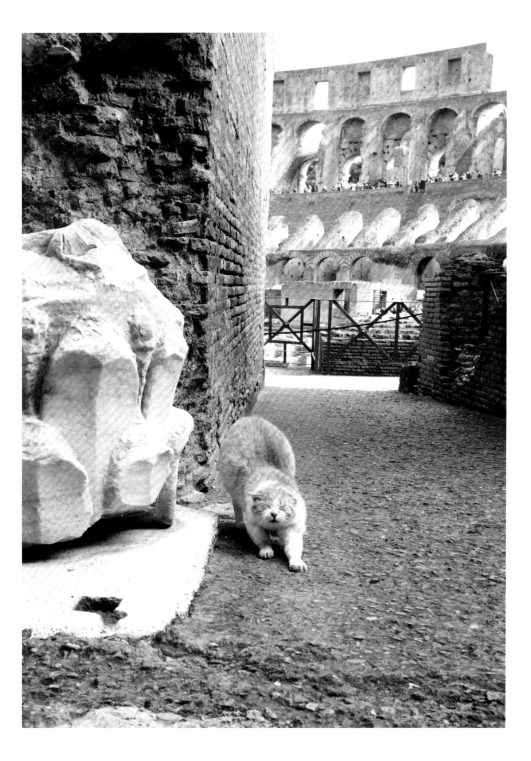

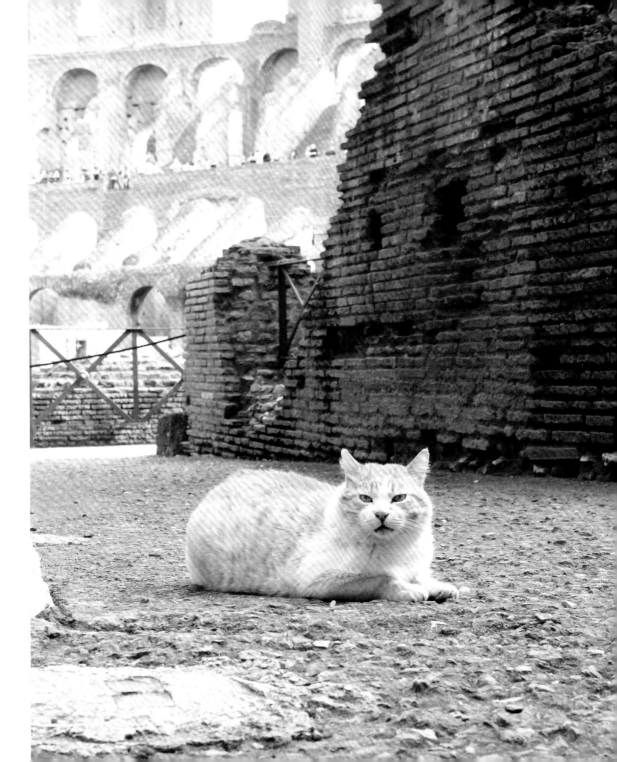

ToRPIGNATTARA

T his culturally diverse Roman district lies southeast of the city center and is known for its vibrant street art and authentic ethnic food, but, like most neighborhoods in Rome, there are always cats if you know where to look. The colony here is spread out over several streets and extends into the nearby Parco Giordano Sangalli, a popular place to view the Aqua Alexandrina, the last of eleven ancient Roman aqueducts built in 226 AD. Empty cat food dishes can be spotted lying near vacant lots or on porches, telltale signs that a gattara has been through that day to feed the feline residents. Look closely and you may find one napping in the shade, awaiting its next meal.

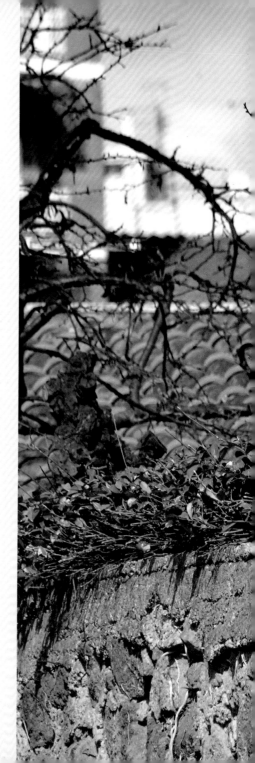

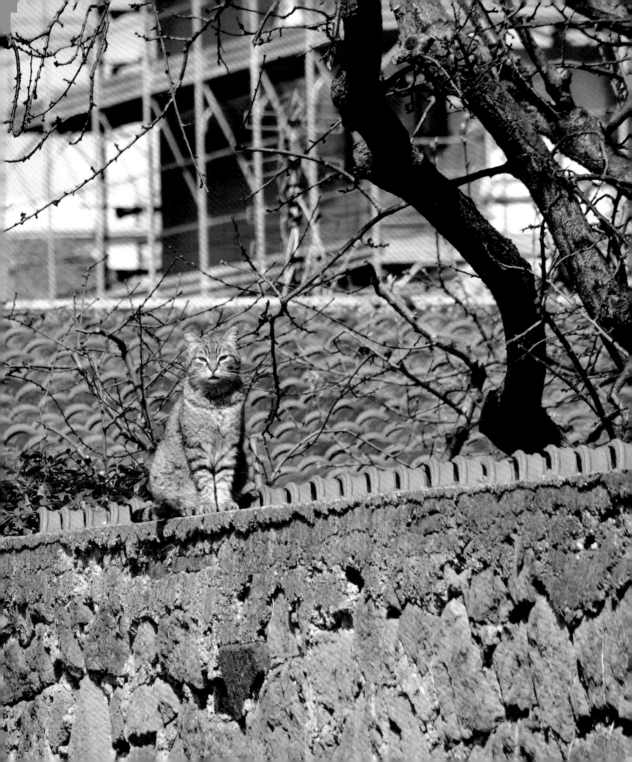

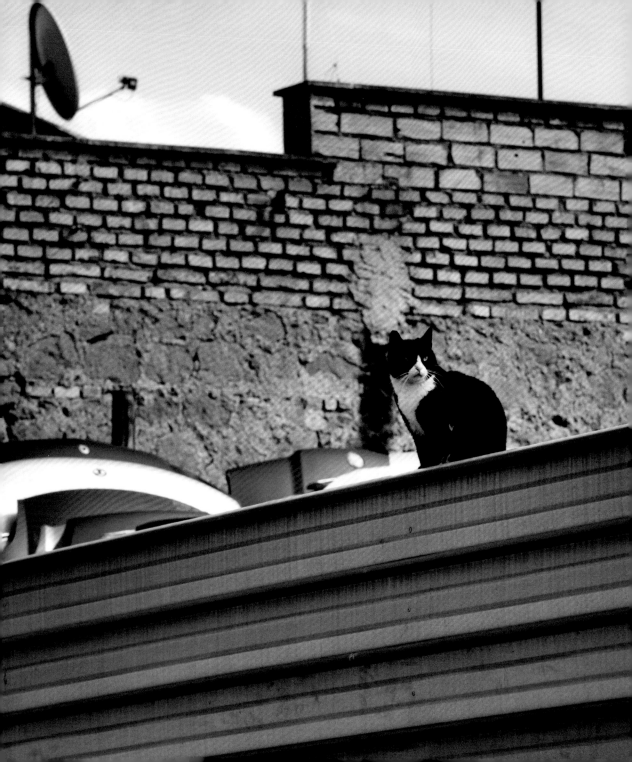

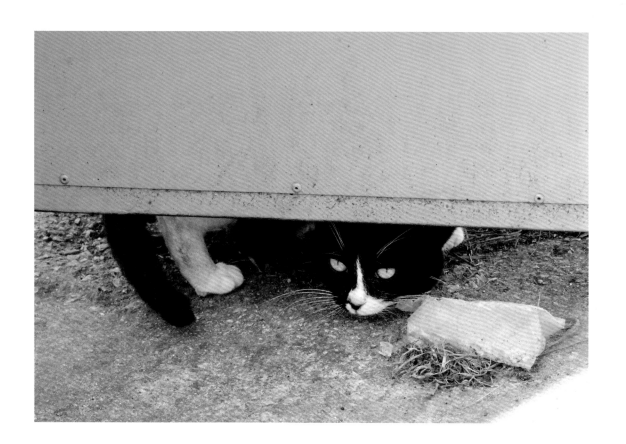

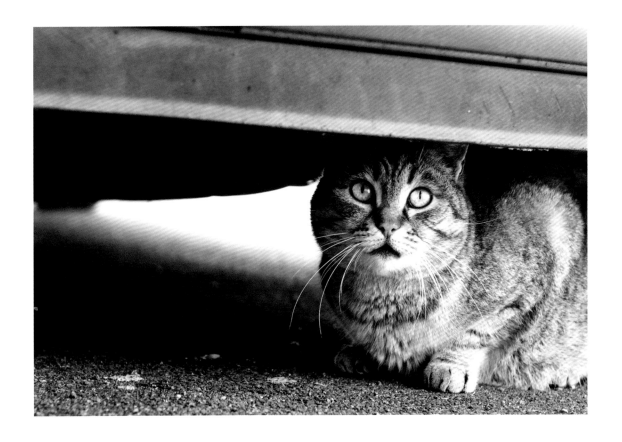

TORPIGNATTARA

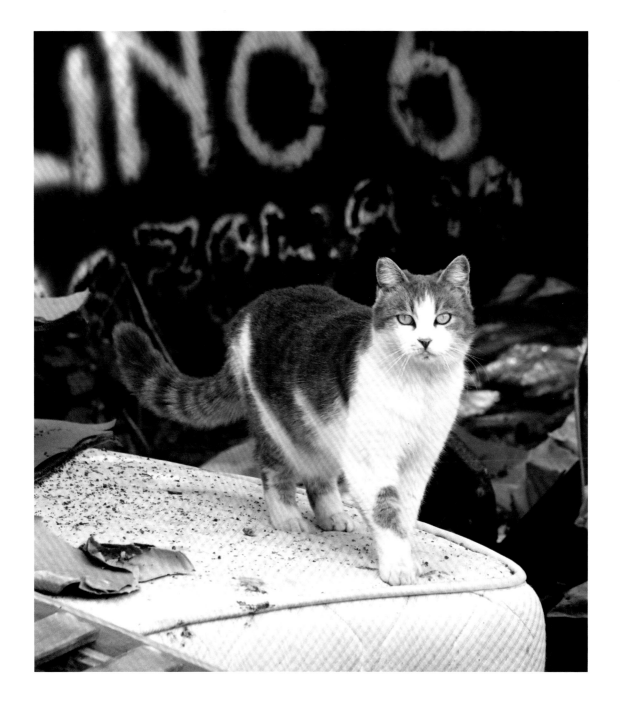

TORPIGNATTARA

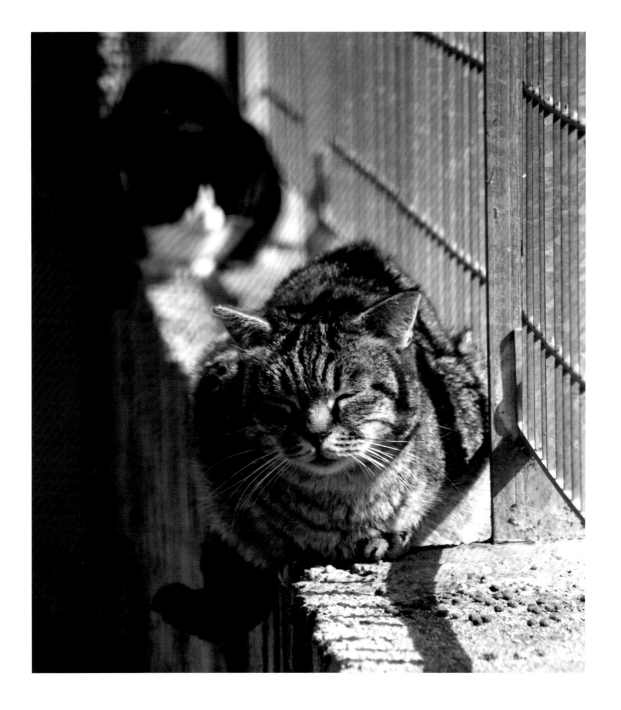

TORPIGNATTARA

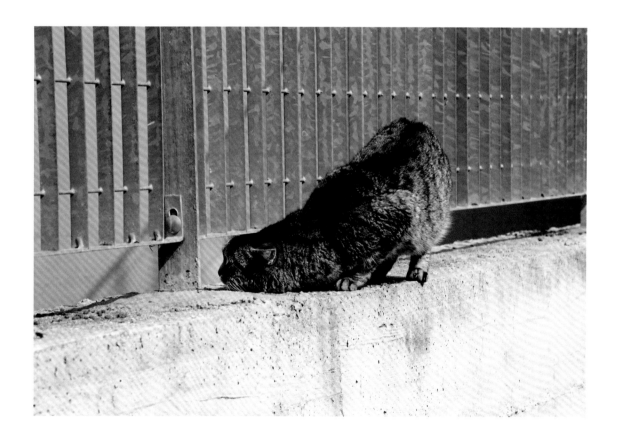

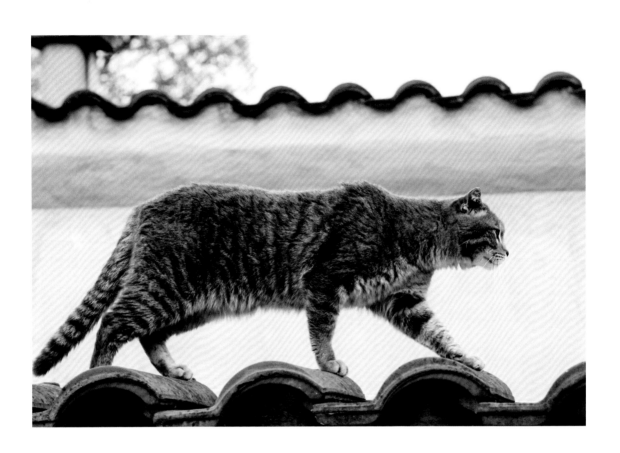

TORPIGNATTARA

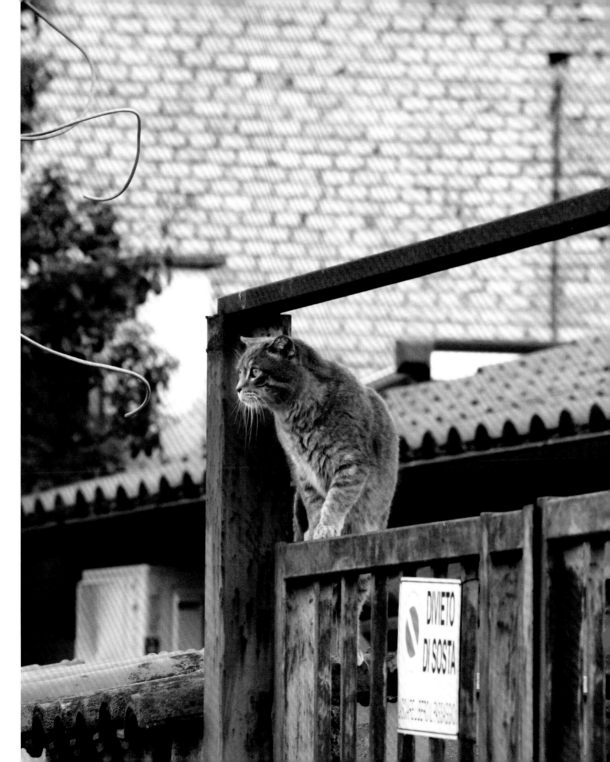

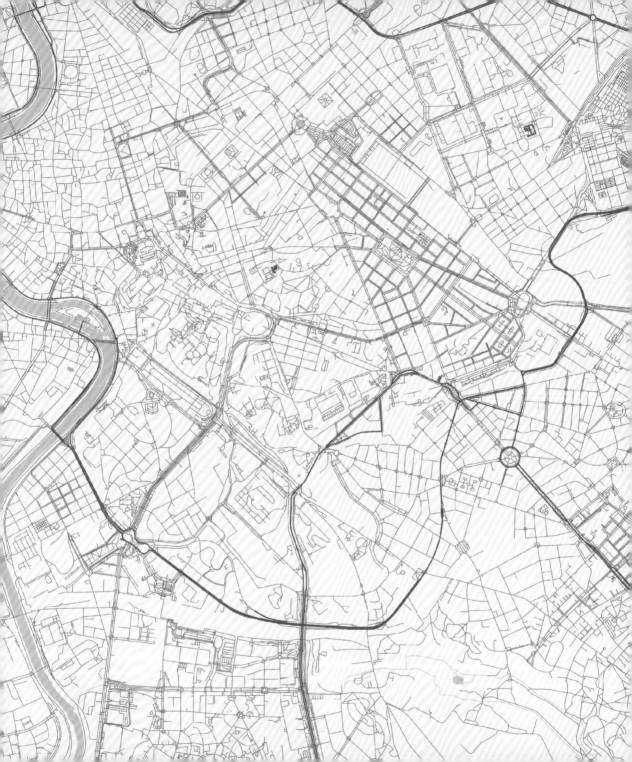

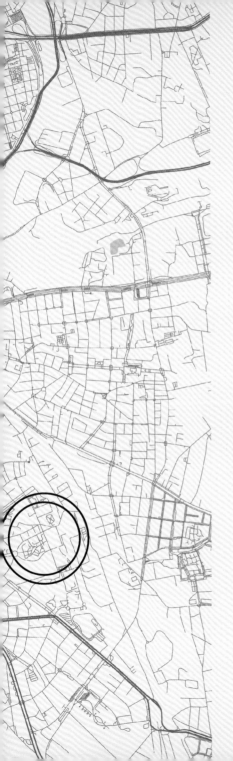

VILLA LAIS

Villa Lais park is a beautiful example of Rome's charming repurposed common areas. The grounds that once belonged to the early twentieth-century Villa Lais house (open to tour) are now a neighborhood park with lush gardens, a playground, dog park, fitness and picnic areas, and, of course, cats. Though the park is the anchor for this colony, few of its cats can be found there. Instead, they are spread out around the surrounding Tuscolano neighborhood. Walking the feeding route that the gattaras take leads you past apartment complexes, coffee shops, and parking lots and into a huge private sports club with views of the Aqua Alexandrina. All along the way, cats can be found alone and in small groups, waiting at their chosen stations for meals and affection.

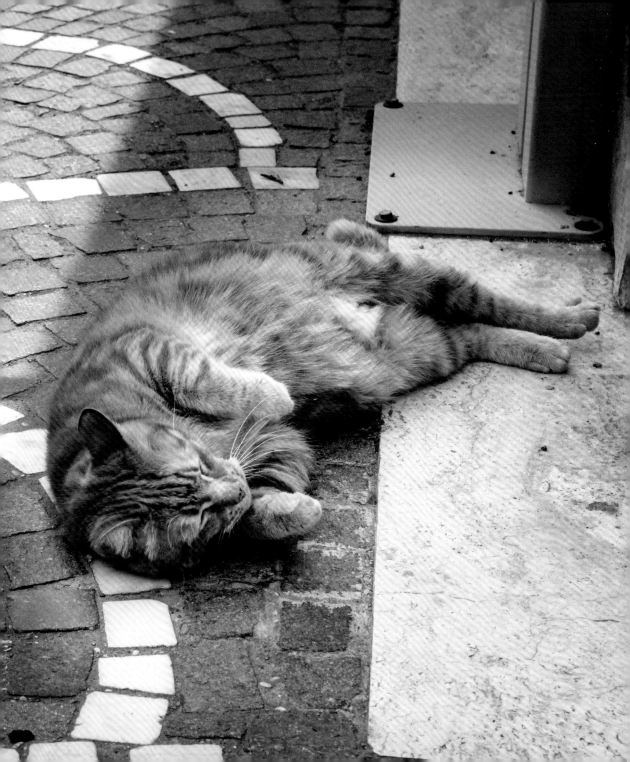

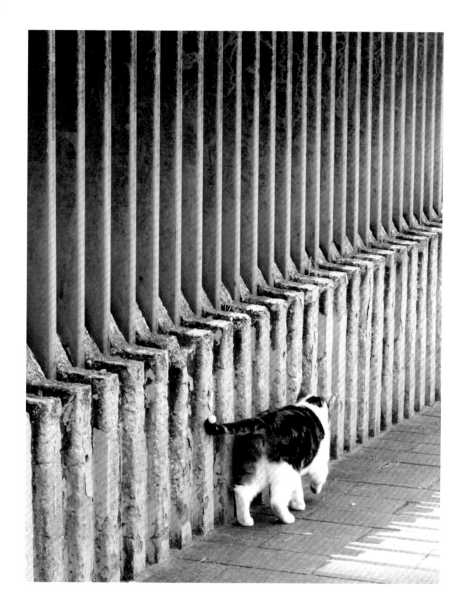

VILLA LAIS

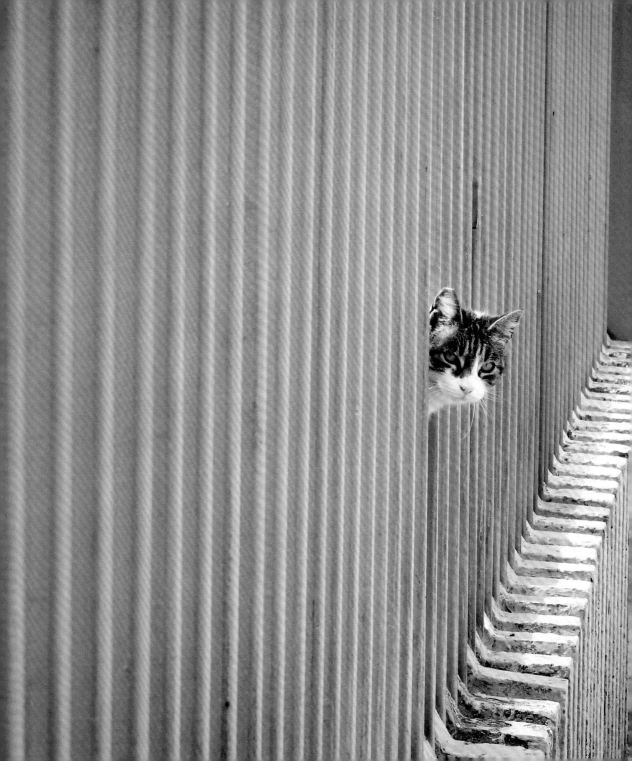

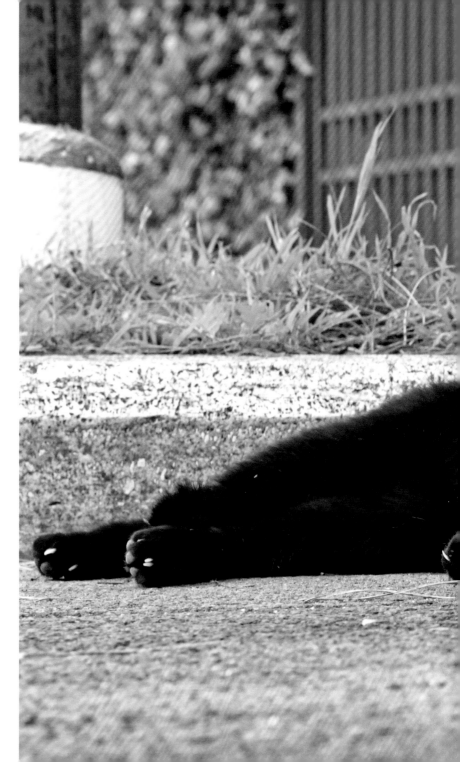

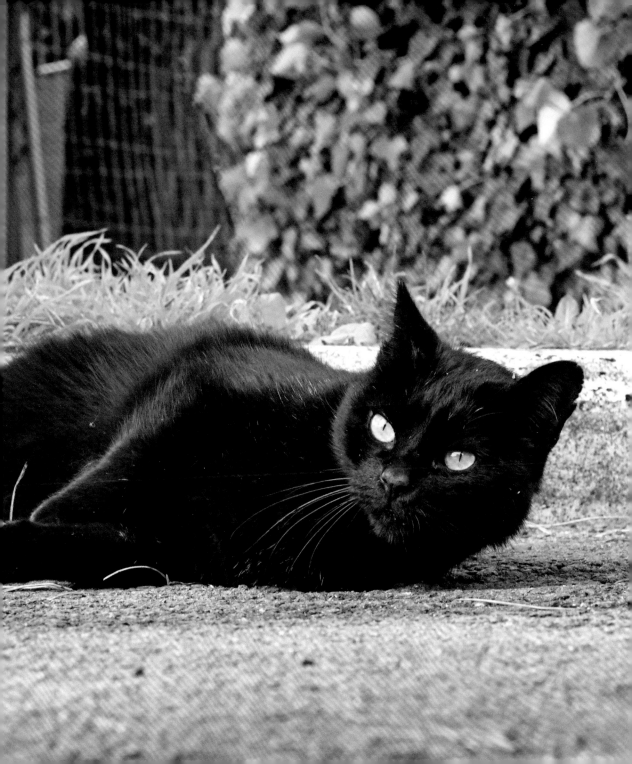

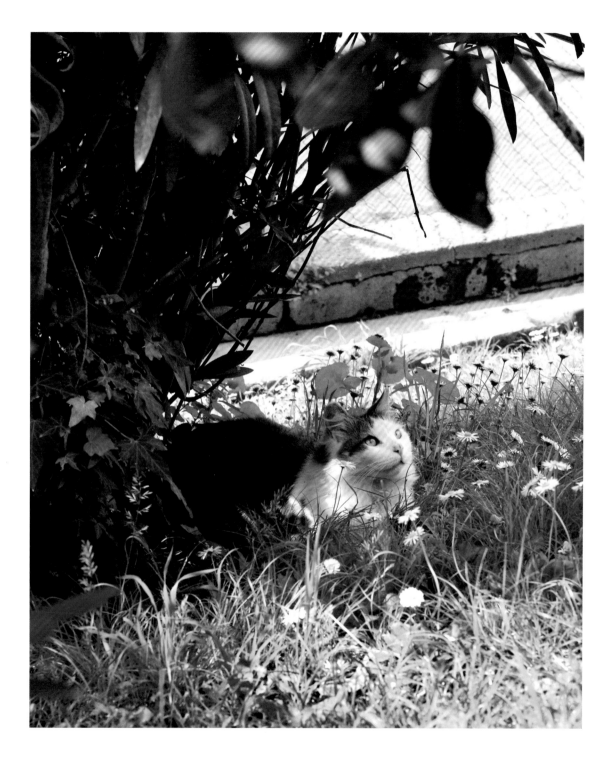

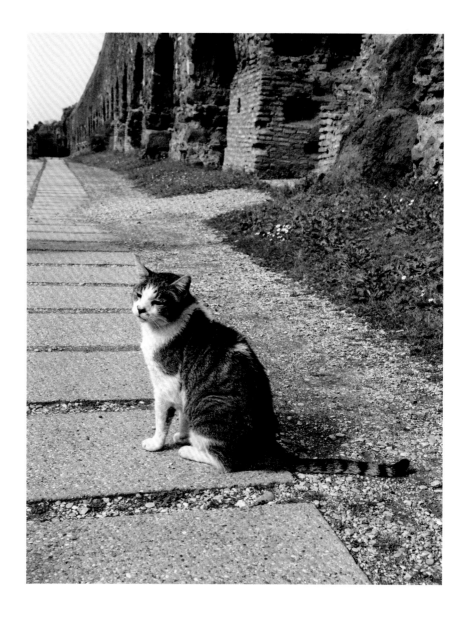

VILLA LAIS

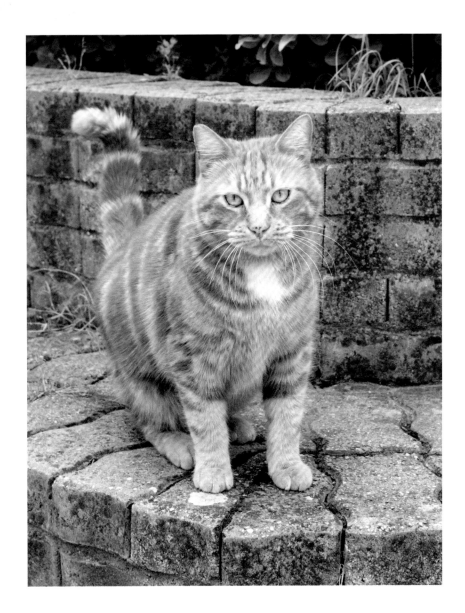

VILLA LAIS

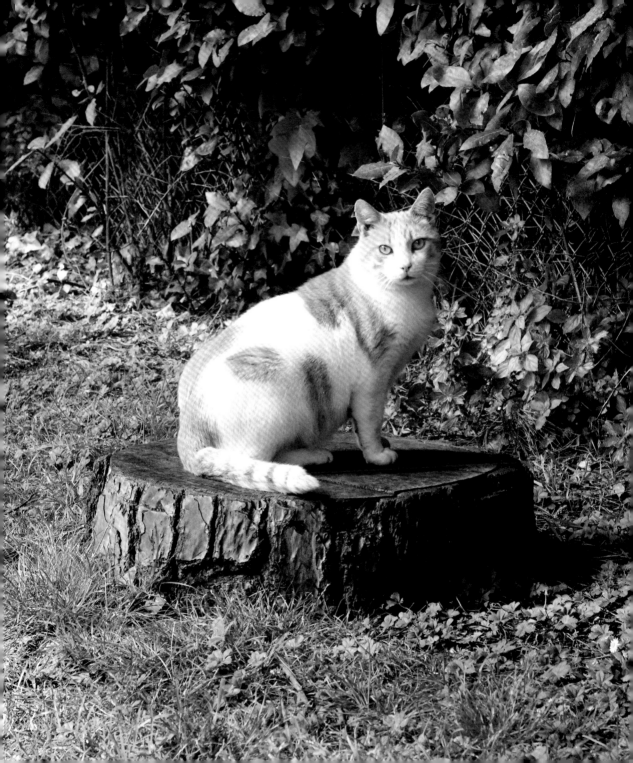

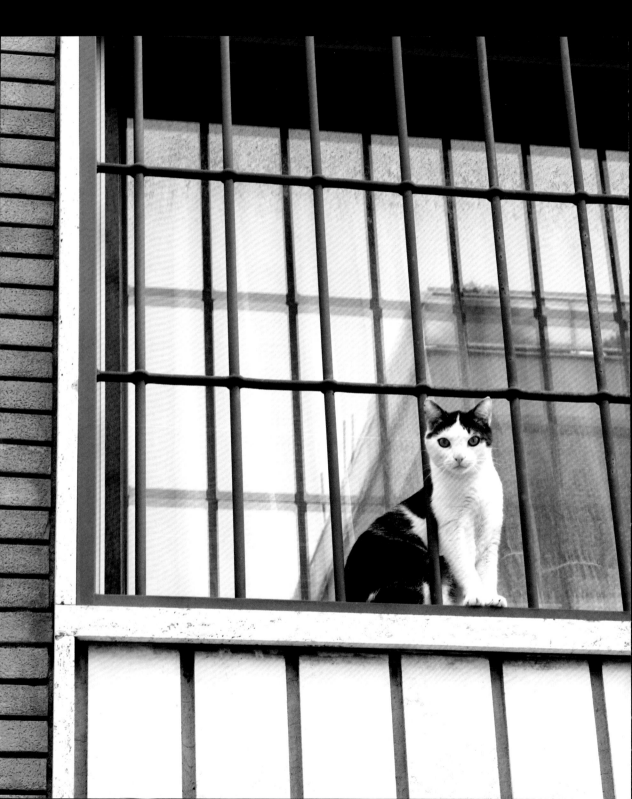

VERANO MONUMENTAL CEMETERY

The sprawling grounds at Verano Cemetery have served as a public burial ground in Rome for twenty centuries. Most Roman citizens were buried here from its modern consecration in 1835 until 1980. With more than two hundred acres of gardens and graves, this is a veritable city of the dead, and the cats are believed to be guardians of peace. Verano is home to the largest cat colony in Rome and volunteers have more than thirty feeding stations around the cemetery, plus a small sanctuary building that houses the older, more fragile felines who can no longer live outside. Small streets wind through the hilly grounds and driving is the best way to access the multitude of sections, but only by walking quietly through the different plots will you find the feline guardians winding around headstones and sitting quietly observant on the steps of mausoleums.

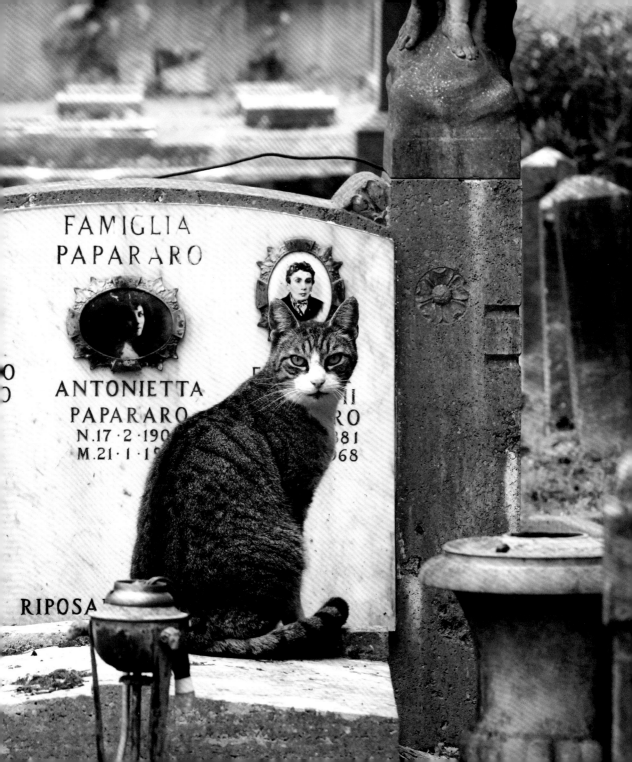

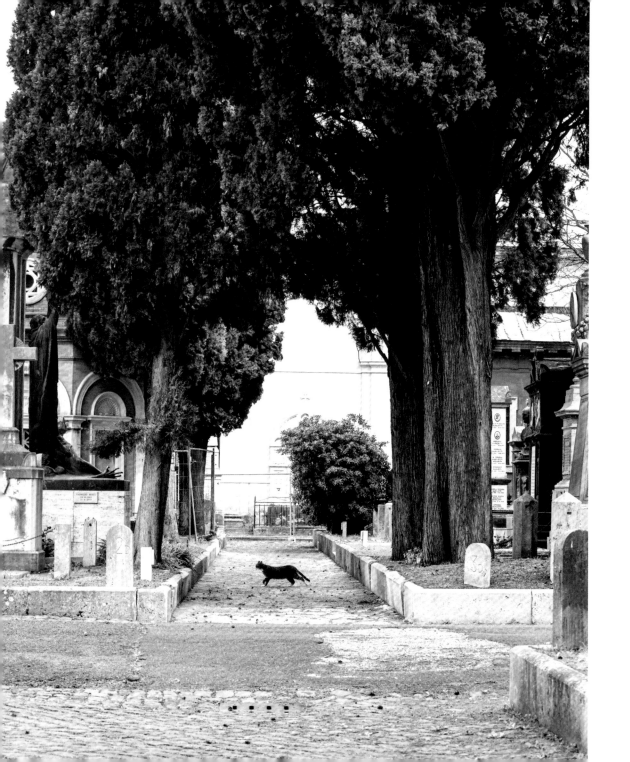

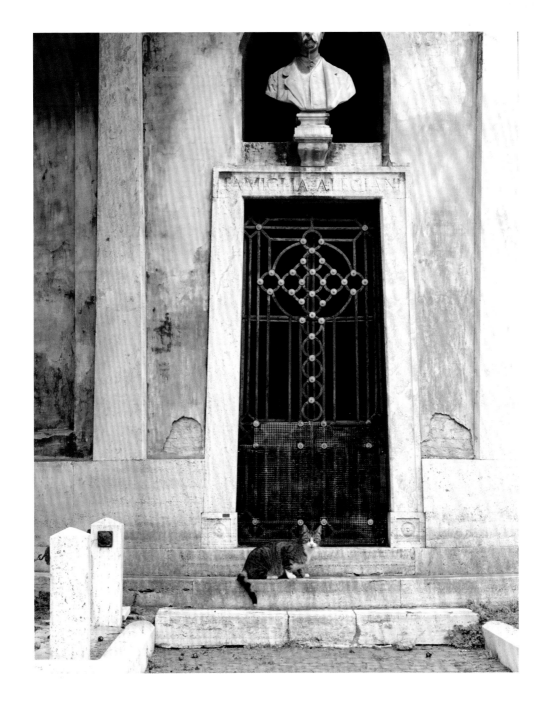

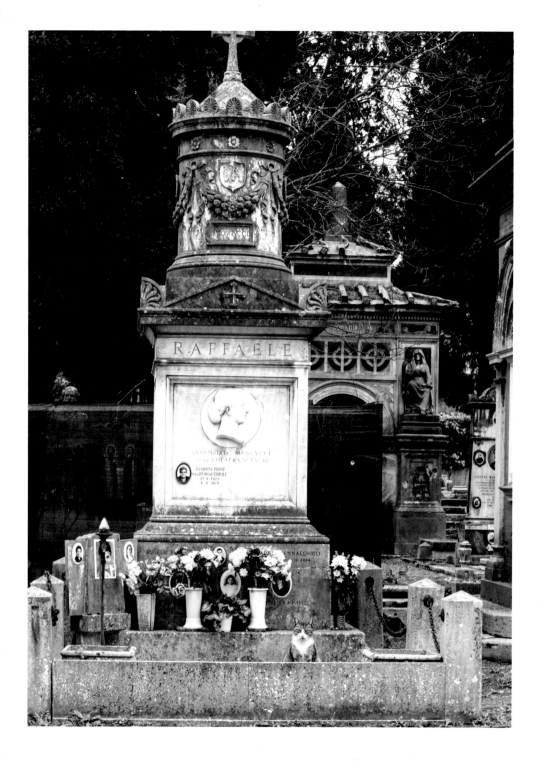

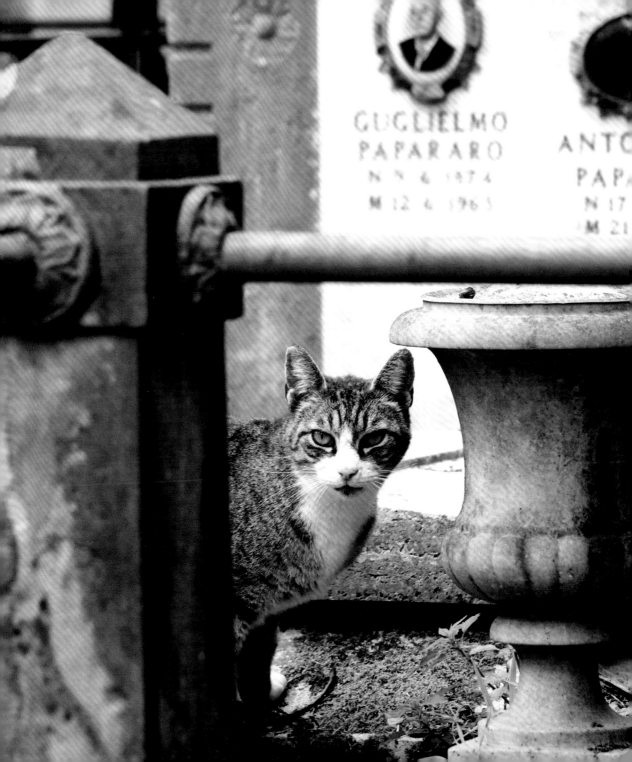

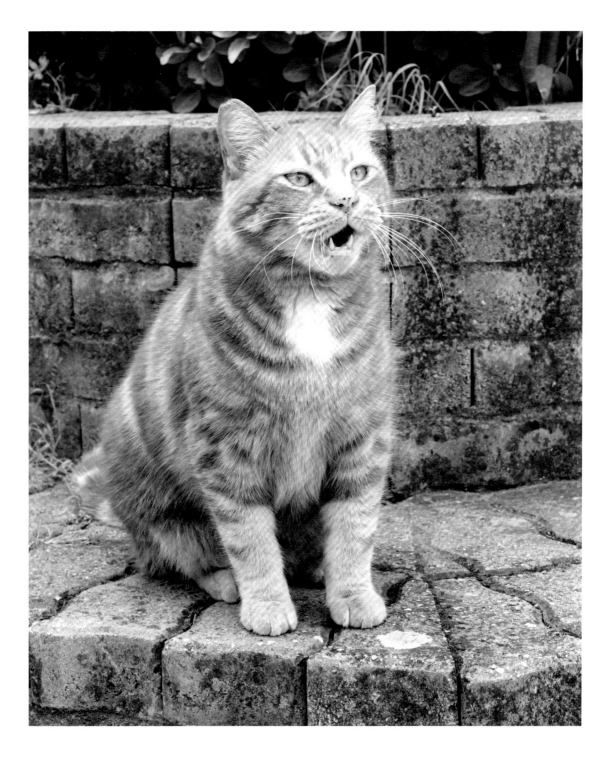

ACKNOWLEDGMENTS

This book was a wisp of a dream haunting the most indulgent parts of my mind for over a decade. I am so grateful to my agent, Joan Brookbank, along with Jennifer Thompson at Princeton Architectural Press, for making it a reality.

Thank you to my marvelous Princeton crew: Sara Stemen, Natalie Snodgrass, and Paul Wagner.

To Anna Simbula, my hostess in Rome, who through such sparkling fate was a cat lover: I would have been truly lost without you. Also to Cinzia Lanni: thank you for introducing me to your beautiful neighborhood and charming feline charges.

Finally, thank you to my family for doing all the hard work at home while I was away communing with cats in the Eternal City.